O9-ABE-519

Bethany Christian Schools Library
Goshen, Indiana

# Mark Rothko

BY KLAUS OTTMANN

Bethany Christian Schools Library
Goshen, Indiana

THE WONDERLAND
PRESS

Harry N. Abrams, Inc., Publishers

**THE WONDERLAND PRESS**

The Essential™ is a trademark
of The Wonderland Press, New York
The Essential™ series has been created by The Wonderland Press

Series Producer: John Campbell
Series Editor: Harriet Whelchel
Series Design: The Wonderland Press

Library of Congress Catalog Card Number: 2002114124
ISBN 0-8109-5826-0 (Harry N. Abrams, Inc.)

Copyright © 2003 The Wonderland Press
Published in 2003 by Harry N. Abrams, Incorporated, New York
All rights reserved. No part of the contents of this book may
be reproduced without the written permission of the publisher

The Wonderland Press is deeply grateful to Christopher Rothko for assistance in the preparation of this book.
Unless otherwise noted, all images are courtesy of the National Gallery of Art, Washington, D.C.
Courtesy Art Resource, NY: pages 29, 30, 41, 63, and 95
Digital Image of MoMA on page 41 is © The Museum of Modern Art/Licensed by SCALA/
Art Resource, NY
Henri Matisse, *The Red Studio,* is © Succession H. Matisse, Paris / ARS, NY
Courtesy of Christopher Rothko and Kate Rothko Prizel: pages 4, 14, 22, 54, 62 (left image), 68, 74, 76,
78, 79, 87, 92, 107, 108, and 109
Photograph by Hans Namuth. Collection Center for Creative Photography, The University of Arizona.
© 1991 Hans Namuth Estate: page 4
Photograph by Regine Bogat: page 87
*For works on canvas:*
© 1998 Kate Rothko Prizel & Christopher Rothko / Artists Rights Society (ARS), New York
*For works on paper:*
© 2003 Kate Rothko Prizel & Christopher Rothko / Artists Rights Society (ARS), New York
All works are oil on canvas unless otherwise noted
On the endpapers: Detail from *Untitled (Harvard Mural Sketch).* 1962. Oil, acrylic, and mixed media
on canvas. 69 $^1/_8$ x 56 $^1/_8$" (175.6 x 142.6 cm)

Printed and bound in China

Harry N. Abrams, Inc.
100 Fifth Avenue
New York, NY 10011
www.abramsbooks.com

Abrams is a subsidiary of

LA MARTINIÈRE
GROUPE

# Contents

Bethany Christian ~~~~~~~ Library
Goshen, Indiana

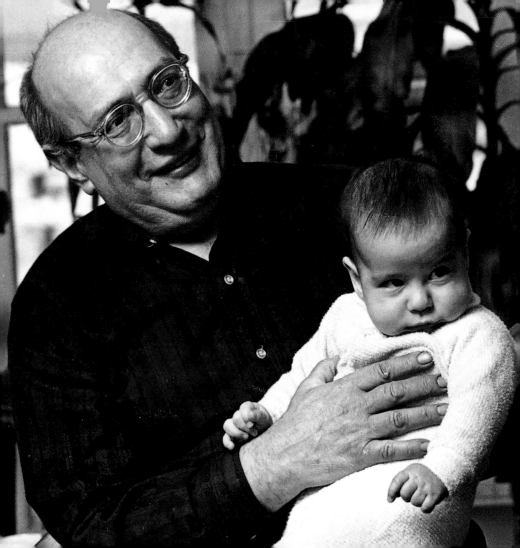

# There is more to this than meets the eye

During his retrospective exhibition at the Museum of Modern Art in New York in 1961, Mark Rothko was asked how long it took him to paint a particular painting that seemed to consist of merely a few large, formless blotches of color on canvas. Rothko responded dryly, "I'm 57 years old and it took me all my life to do it."

This statement tells a lot about Rothko:

- His paintings are not as simple as they seem.

- He came to abstract art only gradually and tentatively, having struggled to express himself for more than half of his life.

- He seems to have become an artist almost by chance.

- He was not a "fast" painter.

- He had a "thing" for dramatics.

OPPOSITE
Mark Rothko with son Christopher 1964

**Sound Byte:**
*There is no such thing as good paintings about nothing.*
—MARK ROTHKO, in letter to Edward Alden Jewell, art editor, *The New York Times,* 1943

**BACKTRACK:**
**ABSTRACT EXPRESSIONISM**

Abstract Expressionism, often called "AbEx," was a movement in American painting throughout the 1940s and 1950s that established New York's dominance over Paris as the leading center of the art world. The most prominent American Abstract Expressionist painters were Jackson Pollock, Mark Rothko, **Willem de Kooning** (1904–1997), **Franz Kline** (1910–1962), and **Barnett Newman** (1905–1970). Most of these artists worked and lived in New York City and are also referred to as the **New York School.**

There are two distinct approaches within Abstract Expressionism:

- **Action Painting** (a.k.a. **Gesture Painting**), represented by Pollock's chance drippings of commercial paints on raw canvas, and de Kooning's richly colored, expressive brushstrokes.

**Mark Rothko** (1903–1970) is generally considered, along with **Jackson Pollock** (1912–1956), the preeminent artist of his generation. He is closely identified with the **New York School,** a group of painters who emerged during the 1940s and reinvented American art. Their radical and unique contribution to Modern art became known as **Abstract Expressionism.** Rothko was one of the most prominent pioneers of *color-field* painting (see sidebar on page 7), through which he became known for works of great emotional and even spiritual depth.

As we will see, Mark Rothko did not become an abstract painter overnight. For more than half of his life, he had been painting in a *figurative* style (i.e., recognizable forms of human figures, etc.). Rothko's road to abstraction was a bumpy one, filled with obstacles—many of his own making. (Rothko suffered from unending existential doubt and anguish.) He was an outsider, largely self-taught, and more burdened by his own past than by art history. Yet, despite all this, he forever changed the way we perceive color in art.

Rothko's artistic development essentially occurred in three phases:

- From the 1920s to the 1930s he painted figures, still lifes, and narrative street scenes.

- From 1940 to 1946, he created semi-abstract "mythological" paintings that led to a greater sense of freedom from representational constraints.

- In 1946, he moved into pure abstraction, arriving in 1949 at the signature style that characterized his work until his death in 1970. This style consisted of two or three floating rectangles of color painted against a monochrome background.

## The many faces of Rothko

Mark Rothko is one of America's most celebrated painters. His works sell at record prices today and he is one of a very few American artists whose creations adorn a U.S. postage stamp and also can be seen as props in Hollywood movies. (One can spot a Rothko painting in the background of a scene in the 1990 remake of *Sabrina*, starring Harrison Ford.)

But it is also the story of a young Jewish boy, born in an obscure Russian town near the Polish border, who grew

**BACKTRACK, continued**

- **Color-Field Painting**, represented by Rothko and Newman, in which flat, thin, diaphanous paint is used to achieve quiet, almost meditative effects.

Traits that distinguish the works of all Abstract Expressionists are:

- The paintings are non-representational.

- They are painted in large, spontaneous, and richly emotional gestures.

- The artists use a form of improvisation similar to *automatism*, a method of "automatic" painting first employed by the French Surrealist artists and poets of the 1920s, to unleash basic, creative, instinctual forces hidden deeply in the unconscious mind.

up in poverty and in an atmosphere of great political oppression. He was separated for three years from his father, who had emigrated to the United States ahead of his family, and when he was finally reunited with the man in Oregon, Rothko lost him to cancer only months later. The young boy would remain forever trapped inside this giant of American art and his childhood longings would manifest themselves over and over in his works.

Generally serious of demeanor, Rothko battled depression at numerous points during his life. Despite this, he remained quite outgoing and socialized a great deal with artists of his generation. His dry, caustic wit amused his friends, but, along with his strong intellectual stance, at times intimidated others. As the painter **Brice Marden** (b. 1938) tells it, Rothko was commonly described by younger artists as a "big bear" whom none of them dared to approach on sight, fearing that the artist would "bite their heads off."

Rothko was obsessed with the idea that abstract painting, more than any other art form, could express the full gravity of religious yearnings and the angst of the human condition. And his extraordinary talent enabled him to transfer these impulses to the canvas with a power and magnetism that stun viewers of his work. It is not uncommon to see people of all ages weeping in front of his canvases. In fact, Rothko's skill in achieving this result—whether intentional or not—perhaps explains why he was once called "the melancholic rabbi."

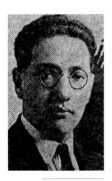

Mark Rothko featured in a September 18, 1921 newspaper article announcing his graduation from Lincoln High and his enrollment at Yale University

Rothko's art, like his life, was at the same time simple and complex. He moved back and forth between his creative instincts and the business realities that faced him. Despite the adulation he received from admirers of his work, Rothko struggled against his own success. Yet he was one of the greatest and most successful painters of his generation. Moreover, he made it look so easy, even though "easy" was not a word in Rothko's vocabulary.

## An extraordinary young man

*And so the story begins:* Mark Rothko was born **Marcus Rothkowitz** on September 25, 1903, the youngest child of a pharmacist, **Jacob Rothkowitz** (1859–1914), and his wife, **Anna Goldin Rothkowitz** (1870–1947), in the Russian city of Dvinsk (today Daugavpils, Latvia). Dvinsk was located at the time within the boundaries of the "Pale of Settlement," then the largest Jewish ghetto in the world. Extending from the Baltic in the north to the Black Sea in the south, along the western borders of Russia, it was inhabited by five million Jews who were confined there by the Russian Empire at the time when thousands of Polish Jews came across the border into Russia in search of work. Its anti-Semitic laws, which

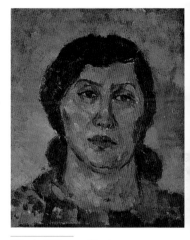

*Head of Woman (Sonia Rothkowitz, the artist's sister)*
c. 1932. Oil on canvas
17 3/8 x 14 5/8" (44.1 x 37.1 cm)

stripped Jews of their rural landholdings, led to the mass emigration of millions of Jews to the United States in the following decades.

Other famous Jewish-Americans whose families emigrated from the ghetto include:

- **Kirk Douglas** (b. 1916), actor
- **Jerome Robbins** (1918–1998), choreographer
- **Aaron Copland** (1900–1990), composer

When Rothko's father emigrated to America in 1910, he joined his brother in Portland, Oregon. Rothko was seven years old at the time and would not see his father again for three years.

Photograph of downtown Portland, Oregon. c. 1915–20

In 1911, after securing employment as a pharmacist in Portland, Jacob arranged for his two older sons, Albert and Moise, to leave Russia for America. By 1913, he had saved enough money for his wife, Anna, his daughter Sonia, and his youngest son, Marcus, to sail on board the S.S. *Czar* from the Russian port of Libau to Ellis Island, New York. After a brief stay with relatives in New Haven, the ten-year-old Marcus Rothkowitz traveled with his mother and sister to Portland, and was finally

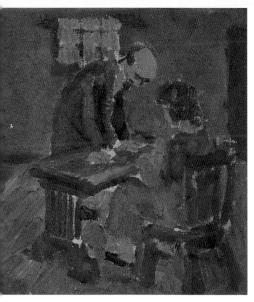

*Conversation.* c. 1932
Oil on linen
11 x 10" (27.9 x 25.4 cm)

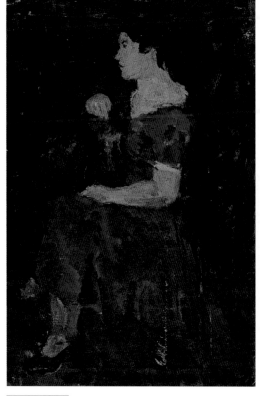

*Minna [or] The Blue Dress.* c. 1932
Oil on linen. 29 5/8 x 19 11/16" (75.3 x 50 cm)

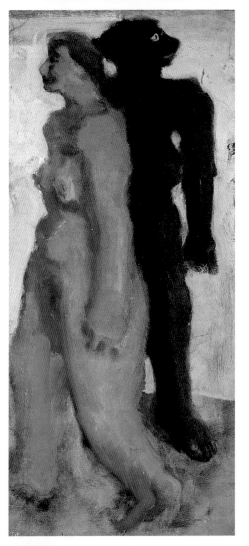

reunited with his father and two brothers, who lived in the southwest part of town known as "Little Russia." One imagines Marcus's deep sorrow and pain, however, when, only seven months later, in March of 1914, his father died of colon cancer at the age of 55. Young Marcus found himself again without a father, this time in an unknown country where he would never feel entirely at home. He did not speak its language, nor did he understand its culture. Jacob's death made it necessary for the children to get jobs.

Despite his sensitive nature and somewhat fragile health, Marcus worked as a newspaper delivery boy before school hours, frequently showing up at school with a bloody nose from having been beaten up by his stronger "competitors." Despite the hardship, he completed high school in

only three years—a notable achievement at the time. He had taken drawing and painting classes and had also taught himself to play the mandolin and the piano. Clearly, the boy's artistic instincts were emerging at a young age.

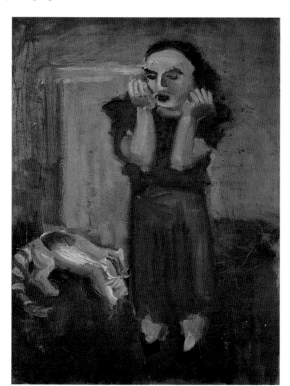

OPPOSITE PAGE
*Nude.* 1933
Oil on canvas
39 1/2 x 17 5/8"
(100.3 x 44.8 cm)

LEFT
*Woman and Cat*
1933
Oil on canvas
31 3/4 x 24"
(80.6 x 61 cm)

## Childhood defined by losses

What do we know about the young Marcus?

- He was sickly, sensitive, and prone to being bullied by other kids.

- He grew up without a father.

- He loved music and played the mandolin and the piano.

- He worked as a newspaper boy.

- He excelled in school.

Young Marcus with his brothers and sister in 1913. *From left to right:* Albert (age 18), Sonia (age 23), unidentified man, Marcus (age 10), and Moise (age 21)

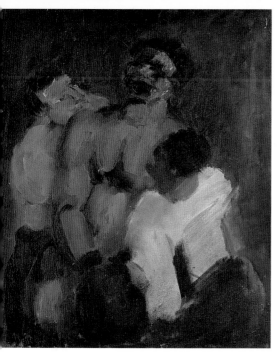

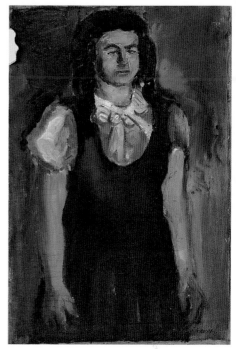

Rothko revered his father and described him as a man of great character and intelligence. He was deeply saddened by the man's death, so much so that he even listed his father's death date in his Yale yearbook as a turning point in his life.

For many years, Rothko remained bitter about the poverty he had experienced as a child. After his father's death, he went to the synagogue every day for a year, as is the Jewish custom. He referred often to the

ABOVE LEFT
*The Pugilist.* 1933
Oil on canvas
21 3/8 x 17 7/8"
(54.3 x 45.4 cm)

ABOVE RIGHT
*Irene.* 1933. Oil on
canvas. 31 3/4 x 21 9/16"
(80.7 x 54.2 cm)

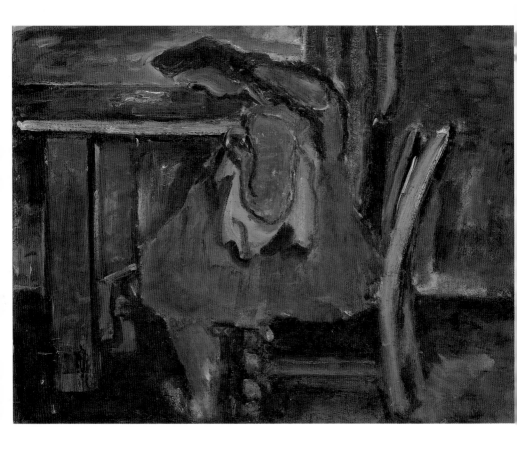

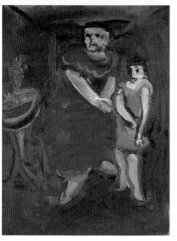

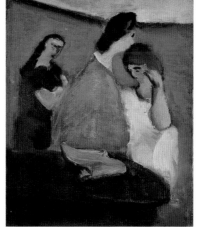

OPPOSITE PAGE
*Woman Sewing*
c. 1934. Oil on
hardboard. 28 x 36 1/16"
(71.1 x 91.5 cm)

LEFT
*Mother and Child*
c. 1934. Oil on
canvas. 25 1/4 x 19 3/16"
(64.1 x 48.7 cm)

RIGHT
*Untitled (Three
Women).* c. 1935. Oil
on canvas. 23 1/8 x 19"
(58.4 x 48.3 cm)

"terrible experience" of having been torn away from his homeland against his will and of seeing his father die only months after arriving in the United States. As a result of these two sources of sadness, there is a strong sense of displacement in most of Rothko's early figurative paintings.

By the time the future artist began attending high school, he was living alone with his mother. She became not only the most important figure in Rothko's life, but also his sole emotional focus. In 1928, he painted a rare portrait of Anna Rothkowitz that shows a weary-looking woman with graying hair, looking pensively away from the viewer. In another

*Rural Scene*
c. 1936
Oil on canvas
27 x 38 ⅛"
(68.5 x 96.8 cm)

work, inscribed "Rothkowitz/Family" and painted around 1936, a mother holds an infant (young Marcus?) in her elongated arms, while the father lovingly bends over the child, who in turn touches the father's face playfully with his hand. Clearly the mother dominates this intimate composition, in which the infant seems to signify pure innocence

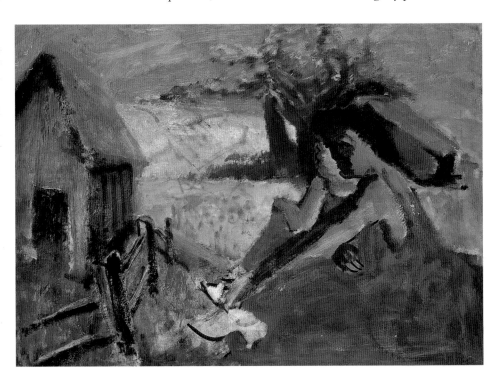

and the father appears almost ghostlike. The painting is formally composed in the Renaissance tradition of the "Holy Family." Paintings that display Rothko's innermost emotional states are rare and limited to his early work. Later, he would learn to express the emotions linked to absence and death more effectively in abstract terms.

As Rothko grew older, he remained close to his mother and frequently returned to Portland from New Haven—and, later, New York—to visit her. On the days of his expected arrivals, she would sit on the sofa from early morning on, looking out the window with the curtains pulled back, waiting for her son to arrive.

## Off to Yale

Mark Rothko at Yale University c. 1921–23

Even though the young Marcus Rothkowitz, newly arrived in America in 1913, spoke only Russian and Yiddish, by 1921 he had graduated from high school and earned a scholarship to attend Yale University—a remarkable achievement for the young adolescent. There, he studied English, French, European history, mathematics, physics, biology, philosophy, and psychology. Ironically, his early goal was to become a lawyer or an engineer. At that time, Yale was strongly anti-Semitic—in fact, there were no tenured Jews on the faculty until 1947. After he had attended Yale for only six months, Rothko found himself in the baffling circumstance of having his scholarship canceled without explanation, as did two of his Jewish classmates who also hailed from

*FYI:* **Who's sorry now?**—When Yale caught up with Rothko after chasing him for years to make loan repayments, the university refused his offer of paintings in lieu of cash. On November 17, 1999, Rothko's painting *No. 15 (Bright Yellow and Red)*—which Sotheby's had estimated at between $4 million and $6 million—sold at auction in New York for $11 million. In 1969, forty-six years after he had dropped out, Rothko received an honorary degree from Yale—which he happily accepted.

Portland. While Rothko was able to continue his studies with a student loan, the money had to be repaid and Rothko found this pressure uncomfortable. In 1923, he decided that he had had enough of Yale. Without graduating, he left New Haven and headed for New York in order to "wander around, bum about, and starve a bit," as he later told it.

**Sound Byte:**

*You have made an enduring place for yourself in the art of this century.*
—KINGMAN BREWSTER, president of Yale University, speaking to Rothko in 1969

## Between the stage and the canvas

Rothko's first passions in life were music and theater. But one day he stumbled onto a figure-drawing class at the Art Students League, a small art school on West 57th Street in New York City, featuring a nude female model. The Art Students League was then the hottest art school in town and Rothko began taking anatomy classes there with the Canadian painter **George Bridgman** (1864–1943).

**Sound Byte:**
*Then one day I happened to wander into an art class. All the students were sketching the nude model—and right away I decided that was the life for me.*

—MARK ROTHKO, c. 1948

The Art Students League was *the* place to be for a young, striving artist. It was run by students for students, as a democratic alternative to the traditional art academy. Its faculty consisted of practicing artists who were hired annually. There were no requirements for admission, no grades, and no degrees. Students could register for individual classes on a monthly basis for a low fee.

While studying at the League, Rothko supported himself with odd jobs. For a while, Rothko's ambitions seemed to hover between the

Mark Rothko
c. 1925

canvas and the stage. Two months after enrolling at the Art Students League in New York, he returned briefly to Portland, where he joined an acting company.

Rothko's continuing fascination with the theater and his study of Shakespeare and the ancient Greeks would play an important role in his understanding of visual art and in the evolution of his mature painting style.

After returning to New York in 1925, he tried unsuccessfully to win a scholarship to attend the American Laboratory Theater. Instead, he enrolled in the New School of Design, and later that year went back to the Art Students League, this time taking mostly still-life classes. Rothko's four-month-long enrollment in the League all but completed his "formal training," even though he hardly viewed himself as an artist. But he had made his choice: He decided to become a painter and to raise his art to the level of music. Mostly self-taught, he

*FYI: Frankly, my dear*—Rothko proudly recalled that the actor **Clark Gable** (1901–1960) had once been his understudy in a Portland theater production—and that he, Rothko, had been the better actor!

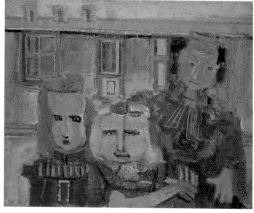

ABOVE
*Figure Composition.* 1936–37
Oil on canvas. 16 ¹/₁₆ x 20 ¹/₁₆"
(40.7 x 50.9 cm)

LEFT
*Interior.* 1936. Oil on hardboard
23 ⁷/₈ x 18 ¹/₄" (60.6 x 46.4 cm)

would later describe himself as "provincial about art." An outsider, who even in 1970 declared that he would never feel entirely at home in a land to which he had been transplanted against his will, he was not thwarted by intimidating predecessors. Rothko would later say that he had "nothing to lose, and everything—a world—to gain."

## Influences

Despite the few classes that he took at the League, Rothko remained essentially self-taught and acknowledged few influences on his work. The "formal" teachers and artists who influenced him included:

- **Arshile Gorky** (1905–1948), an artist who taught at the New School of Design and whose works would become precursors of Abstract Expressionism.

- **Max Weber** (1881–1961), the Russian-born painter who taught at the Art Students League. He had studied at the prestigious Académie Julien in Paris and was a friend of the Spanish painter **Pablo Picasso** (1881–1973). Through Weber, Rothko discovered the two French painters who would influence him for the rest of his life: Henri Matisse and Paul Cézanne.

- **Milton Avery** (1885–1965), an American artist whose paintings provided the historical link between European Modernism and the American color-field painters by adopting and reinterpreting the sophisticated, sensual use of color in the works of Matisse.

- **Henri Matisse** (1869–1954), whose use of color profoundly influenced the development of Rothko's most important work.

- **Paul Cézanne** (1839–1906), the French Post-Impressionist painter, whose short brushstrokes influenced many of Rothko's early paintings. Weber considered Cézanne a master of composition and advised his students to study Cézanne's paintings for that reason.

- **John Marin** (1870–1953), the leading watercolorist and American landscape painter of his time, best known for his expressionistic watercolor seascapes of Maine and for his views of Manhattan. His works, while always representational, leaned toward the abstract.

## Unholy rabbi

In the late 1920s, the struggling young artist had a variety of day jobs, from fabric cutter in the garment district to sign painter. In 1928, Rothko was hired by a retired rabbi from Portland to assist him with illustrations for a book called *The Graphic Bible*. Rothko was to receive a share of any royalties that accrued above his $600 fee and was promised that he would be credited for his illustrations. But the man of cloth was not a man of his word. When the book was published, only the rabbi's initials appeared on the illustrations—and, to make matters worse, he withheld Rothko's last payment. Rothko consequently sued both the rabbi and his publisher, seeking $20,000 in damages and a share in the royalties. After three months of unusually complex

proceedings that included ten hearings and 700 pages of testimony (300 pages by Rothko himself), two judges, and three lawyers, the court ruled in favor of the rabbi and his publisher. The lawsuit eroded Rothko's faith in the legal system and had lasting repercussions on the artist's life.

## "M. Rothkowitz"

OPPOSITE
*Contemplation*
1937–38
Oil on canvas
24 ⅛ x 32 ⅛"
(61.3 x 81.6 cm)

From the mid-1920s to the late 1930s, Rothko made figurative paintings, still lifes, landscapes, and, in particular, interior and urban scenes that reflected the influence of his teacher, Max Weber. Some of these early canvases, such as *Untitled (Two Jews)* (1924–25) contain areas of unpainted, bare canvas, a practice first employed by the French painter Cézanne in his watercolors and oil paintings. Other works, such as *Untitled (Waiting Room)* (1935) and *Contemplation* (1937–38), feature areas painted as flat grounds that function not as passive backgrounds but as **active** parts of the composition. These practices foreshadow Rothko's mature painting style, which will emerge in the late 1940s and that will feature softly diffused color "objects" floating over equally active, thinly painted grounds.

Rothko signed his paintings sometimes on the front, sometimes on the back of each canvas (the "verso"), and used different versions of his name (e.g., "**M. Rothkowitz**").

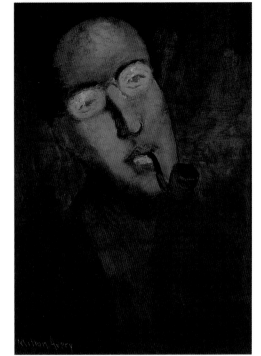

Milton Avery
*Portrait of Mark Rothko.* 1933
Oil on canvas mounted on
masonite. 22 x 19 7/8"
(55.88 x 50.51 cm)

Museum of Art, Rhode Island School of Design, Providence

Like most artists, Rothko had scarce funds, but knew how to stretch his pennies. He made his own stretcher bars, primed his own canvases, and occasionally—to save money—he painted on both sides of the canvas. Sometimes one can see tiny bristles from his brushes in the paintings— an indication that he needed to use the brushes well beyond their life expectancy.

## Hanging out with Avery

In 1927, Rothko met Milton Avery, a painter eighteen years his senior. Avery had never gone to college, and before moving to New York City in 1925, he painted by day and worked at night as a file clerk at the Travelers Insurance Company in Hartford, Connecticut.

While Max Weber may have introduced the avant-garde of Paris to his New York students, it was Avery who brought a new color sensibility to American painting—soon to be surpassed by his "student" Rothko. It did not take Rothko long to join Avery's circle of artist friends who looked to Avery for inspiration. The group included the painters

Adolf Gottlieb
*Sundeck.* 1936
Medium &
dimensions TK

Smithsonian Institution, Washington, D.C.

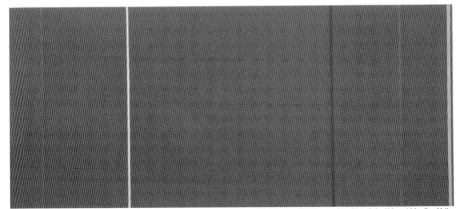

The Museum of Modern Art, New York. Gift of Mr. and Mrs. Ben Heller

Barnett Newman
*Vir Heroicus Sublimis.* 1950–51
Oil on canvas
7'11 ³/₈" x 17'9 ¹/₄"
(2.43 x 5.43 m)

**Adolph Gottlieb** (1903–1974) and Barnett Newman. Rothko soon began to regard Avery as his mentor and would drop in on Avery almost daily to see what he was doing.

> *FYI:* **The name game**—Rothko began to shorten his name to "Marcus Rothko" in the early 1940s. Although he became a U.S. citizen in 1938, he did not legally change his name to "Mark Rothko" until May 16, 1959. His two older brothers took on the more common surname "Roth."

**Sound Byte:**

*Rothko explained to me that Milton Avery was the first person he knew who was a professional artist twenty-four hours a day. And he gave Rothko the idea that that was a possibility.*

—ELAINE DE KOONING, painter, 1962

Rothko, Gottlieb, and Newman spent many "working" vacations together, summering with Avery and his wife, Sally, at an art colony in Gloucester, Massachusetts. There, they swam during the days and looked at each other's paintings for their evening entertainment. In New York, everyone gathered at the weekly sketch classes and at occasional poetry readings held at Avery's apartment on West 72nd Street.

**Sound Byte:**

*I've got to become a great painter because I've found a way to live for three days on a can of sardines and a loaf of bread and the milk I stole from somebody down the hall.*

—MARK ROTHKO, 1928

The Whitney Museum opened in 1931 in Greenwich Village as the private museum of **Gertrude Vanderbilt Whitney** (1875–1942), the great-granddaughter of shipping and railroad magnate **Cornelius Vanderbilt** (1794–1877). She had studied sculpture in Paris and New York and soon began to collect art—primarily the urban realist paintings of **The Eight** and the larger **Ashcan School,** two groups of American painters based in New York who included **John French Sloan** (1871–1951), **Edward Hopper** (1882–1967), and **George Bellows** (1882–1925). She also acquired works by artists of the succeeding movement, known as **Regionalism,** or American Scene Painting, led by the artist **Thomas Hart Benton** (1889–1975).

In 1929, just before the stock market crashed, Mrs. Whitney

## Training "future artists and art lovers"

In 1929, Rothko became a part-time teacher at the Center Academy in Brooklyn, where, until 1946, he taught painting and clay sculpture twice weekly to children who ranged in age from kindergarten through the eighth grade. He was a popular teacher, much loved by the children, and, not surprisingly, he believed his function as the instructor was not to teach technique but to stimulate emotional excitement and to inspire self-confidence in his students.

## Love, marriage, and first exhibition

In the summer of 1932, while vacationing in the Adirondack Mountains in upstate New York, Rothko met his first wife, **Edith Sachar** (b. 1912), a young jewelry designer from Brooklyn. They were married in November, three days after Franklin D. Roosevelt's election to the presidency.

One year later, in the summer of 1933, Rothko and Edith traveled across the continent to Oregon to visit his relatives and to install his first one-person exhibition at

the Portland Museum of Art. Camping along the way, he produced a number of watercolors as gifts for his brothers and sister. Remarkably, he took with him a portfolio of works by his Brooklyn students, and when it came time to install his show at the museum, he insisted on hanging their works alongside his own.

Teaching continued to give Rothko an opportunity to refine his own theories on art. In 1934, he published an article (entitled "New Training for Future Artists and Art Lovers") in the *Brooklyn Jewish Center Review* on the subject of teaching art to children. At the same time, he began to keep a notebook, the "Scribble Book," that brought together his notes from the 1930s for a manual he was preparing on the same subject (i.e., teaching art to children). It later became an important source for art historians who wished to understand Rothko's thoughts during his early years.

## Nine against the Whitney

In 1935, Rothko and eight other artists formed a group that they called **The Ten,** even though there were only nine of them. These nine independent artists—who

**BACKTRACK, continued**

offered to donate her entire collection of 600 American paintings to New York's Metropolitan Museum of Art and to provide funds for a new wing in which to show them.

Hard to believe, but the offer was refused. The heiress, undeterred by their arrogance, made plans to build her own museum, which would be devoted to contemporary artists. Despite its early emphasis on realist art, the Whitney Museum today houses one of the world's foremost collections of 20th-century American art.

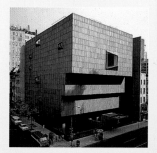

The Whitney Museum of American Art, New York

had no formal gallery affiliations—included **Ilya Bolotowsky** (1907–1981) and Adolph Gottlieb. (Avery could not have joined the group, because he was represented by one of New York's most prestigious galleries, the Valentine Gallery.) The Ten banded together in response to the founding of the Municipal Art Gallery by the City of New York, which was to show art by self-organized groups of ten to fifteen artists (thus, the group's name). Gallery members met once a month to plan shows and discuss art. While it was essentially a leftist organization, many members of the group believed more in art than in politics. In fact, their chief institutional adversary was New York's Whitney Museum, which at the time supported realist and regionalist art—an art movement they regarded as "provincial" and overly political. (Regionalism and American Scene Painting depicted urban and rural poverty in a journalistic, illustrational manner.)

**Sound Byte:**

*In the 1930s, Rothko was so unnoticed by the general critics at that time that he was very bitter about it. They didn't notice him; they didn't even say that he was bad. That's true. He complained about that.*

—JOSEPH SOLMAN, painter and
founding member of The Ten, 1998

**Sound Byte:**

*When I was a younger man, art was a lonely thing: no galleries, no collectors, no critics, no money.*

—MARK ROTHKO, 1962

In November 1938, during the time of the Whitney's biennial exhibition, the Ten mounted a highly publicized exhibition—which they called "The Ten: Whitney Dissenters"—located two doors down the block from the original museum, at the Mercury Galleries on West 8th Street, in Greenwich Village. The group disbanded about 1940, but critics acknowledge its existence as an early force in the development of Abstract Expressionism.

## Provincial about art

Apart from Paul Cézanne's watercolors and paintings, the only other significant influence on Rothko during the 1920s and 1930s was the American painter and printmaker John Marin. Marin often employed watercolor techniques in his paintings by dragging a nearly dry brush across the canvas to achieve lightness and transparency—effects that, together with Cézanne's watercolor technique, inspired Rothko years later to achieve a similar transparency of color in his mature abstract paintings.

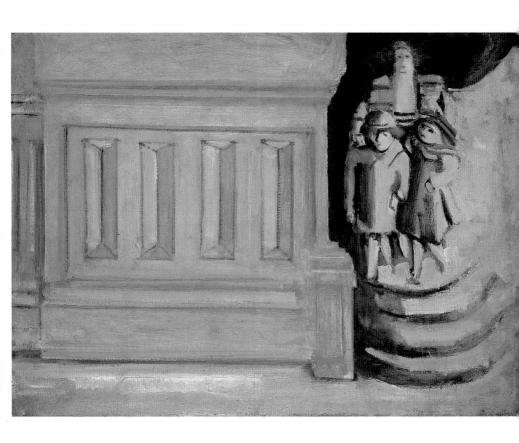

## STREET SCENE, c. 1937

*29 x 40 inches (73.7 x 101.6 cm)*

National Gallery of Art, Washington, D.C.

**When:** Painted about 1937, during the Depression, while Rothko was working for the WPA (see BACKTRACK on page 38), this is one of a series of works from the 1930s depicting New York City streets or subway station interiors, both popular subjects for many artists and writers of the period. The fragmented nature of life in the great modern cities after World War I, as experienced by many writers of the period, was most eloquently described in *The Waste Land*, a book-length poem by the American-English poet and playwright **T. S. Eliot** (1888–1965). The poem was published in 1922 and Rothko had heard it in the early 1930s at the poetry readings in Milton Avery's apartment.

**What:** *Street Scene* is an extremely flat picture that is formally divided into two distinct sections, the scale of each side disproportionate to the other. Each section is dominated by a single color—the left, by an imposing tan structure with large, vertical, rectangular flutes, suggesting a bank or a government building. The right section consists of three gray figures (an adult and two children dressed in heavy overcoats and hats). They confront the viewer, standing formally on a stony, gray, segmented pedestal. Its frontal composition and simple formality resemble a stage set, which reminds us of Rothko's youthful involvement in acting and his lifelong interest in the theater.

**What it teaches us:** Notations in the "Scribble Book," Rothko's notebook from the late 1930s, reveal thoughts about what he called "space emotion," and how formal decisions (such as scale) were, for him, also emotional ones. Here Rothko's ultimate concern as a painter was not to convey realism but to evoke an emotional space in the stark contrast between the dehumanized, urban architecture and the group of desolate human figures.

After the stock market crash of 1929, American artists joined millions of their fellow citizens in unemployment, dispossession, and poverty. In 1935, with an initial appropriation of $5 million, the Federal Arts Project of the **Works Progress Administration** (WPA) was established by President **Franklin D. Roosevelt** (1882–1945) to reduce unemployment caused by the Depression. The project was by far the largest effort in history to aid individual artists with government funds. It was conceived as a work-relief program for all artists. The project's scale was immense: By 1938, it had produced more than 350,000 photographs, 100,000 easel paintings, 17,000 pieces of sculpture, 95,000 prints, and 2,500 murals. A total of about 5,500 painters, sculptors, craftspeople, and photographers received an average of $95 per month in salary. The total federal investment was about $35 million.

## What to remember about Rothko's early style:

Before moving on to the next stage in Rothko's life, we can sum up what we've seen so far of his work by listing a few primary features that characterize it:

- In his early career, he painted figurative, urban, interior, psychological, and street-scene compositions.

- He often used the compression of space and the elongation of the human figure to create an "emotional space" in his work.

## Painting for the Government: The WPA Years

Between 1937 and 1939 Rothko worked happily in the Easel Division of the Works Progress Administration's Federal Arts Project, joining his friends and fellow painters Milton Avery, Jackson Pollock, **Ad Reinhardt** (1913–1967), Pollock's wife, **Lee Krasner** (1908–84), and eight out of the nine members of The Ten.

The easel painters worked in their own studios, where they were free to develop their own styles. They were granted more independence than the muralists, who

**FYI:** Many of Rothko's New York street and subway paintings were executed while he worked for the WPA.

were usually expected to paint "American" scenes, but their studios were subject to sporadic inspections by WPA supervisors. Like all WPA artists, easel painters were required to work ninety-six hours a month and had to punch a card at the local WPA office twice a day, at 8:00 AM and 4:00 PM. (Jackson Pollock once appeared in his pajamas in order to meet the morning deadline.) The artists were required to

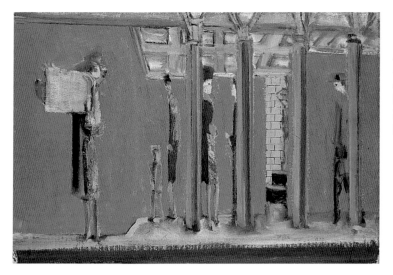

*Untitled (subway)*
c. 1937
Oil on canvas
20 1/8 x 30 1/8"
(51.1 x 76.2 cm)

The Modern opened in temporary quarters on the 12th floor of 730 Fifth Avenue in November 1929, barely ten days after the stock market crash that threw America into financial chaos.

The inaugural exhibition of paintings by the French Impressionist and Post-Impressionist painters **Vincent van Gogh** (1853–1890), Paul Cézanne, **Paul Gauguin** (1848–1903), and **Georges Seurat** (1859–1891) attracted 50,000 visitors in five weeks.

MoMA was the first American museum to exhibit modern French art. In 1939, the museum was relocated to a newly designed aluminum-and-glass building on West 53rd Street.

submit one oil painting every four to six weeks so that a steady flow of works could be allocated to public buildings throughout the United States.

## Kootz's challenge

In the summer of 1941, *The New York Times* published a widely read and controversial letter by **Samuel Kootz** (1898–1982), an advertising executive and self-proclaimed art impresario (he later opened a gallery and became Picasso's American dealer). Kootz called on young American artists to turn away from France as inspiration for their works and instead to create a new, *independent* American art: "Isn't there a new way to reveal your ideas, American painters? . . . Now it's time to experiment . . . God knows you've had a long rest." Kootz's letter elicited many angry responses from artists proclaiming that experimental art was indeed being produced in America, just not shown in galleries. Kootz stood corrected. He accepted invitations to visit artists' studios and, consequently, in 1942, he organized a large exhibition of 179 works by seventy-two contemporary American painters at R. H. Macy's department store. Among the better-known Modernist painters selected

by Kootz was a "Marcus Rothko," who, within ten years, became (with Jackson Pollock) the most celebrated practitioner of the first independent American art movement.

## On the road to Abstraction

In 1940, Rothko temporarily separated from his wife, Edith (they divorced in 1943), and pretty much stopped painting for almost one year to study Greek mythology. Living alone, he spent much of his time with fellow painter Adolph Gottlieb, who lived nearby. Together they developed a new painting style and content: mixing automatic drawing (imported by the exiled French Surrealists) with mythological stories. Concurrently, they filled their canvases with personages and symbolic animals from Greek mythology. Rothko exhibited these works for the first time in the 1942 exhibition at Macy's department store. It was a major step for him toward abstract, nonrepresentational painting.

Rothko had written in his notebook that the artist must look within himself, like an "anthropologist or archaeologist" of the unconscious, for the myths buried within the self. As early as the late 1930s, he had begun to explore mythological subjects for his paintings, inspired by his

**BACKTRACK, continued**

Today it houses a comprehensive collection of primarily American and European art, ranging from the late 19<sup>th</sup> century to the present.

However, during the 1930s and 1940s, MoMA was almost entirely focused on European art. It repeatedly refused to exhibit works by American abstract artists, such as those created by The Ten. This prompted painter Ad Reinhardt in 1940 to distribute a sarcastic broadsheet with the headline: "How Modern Is the Museum of Modern Art?"

Lobby of The Museum of Modern Art, New York. Designed by Cesar Pelli

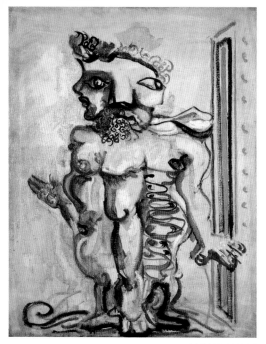

*Untitled.* 1940–41
Oil on canvas. 36 1/16 x 28 1/16"
(91.6 x 71.3 cm)

enthused reading of the German philosopher **Friedrich Nietzsche** (1844–1900). Rothko's youthful interest in acting and his early studies of the Greek tragedies and Shakespeare's plays, combined with his reading of Freud and Nietzsche, were crystallized in these new works.

## Delving into philosophy: Nietzsche's *The Birth of Tragedy*

Rothko was extremely well read, but few books influenced him as much as *The Birth of Tragedy from the Spirit of Music* (1872) by the German philosopher Friedrich Nietzsche. It was Nietzsche's text that led him eventually to abandon figuration and become an abstract painter.

**Sound Byte:**
*It was with the utmost reluctance that I found the figure could not serve my purposes…. But a time came when none of us could use the figure without mutilating it.*

—Mark Rothko, 1958

Nietzsche was a natural match for Rothko. The latter's passion for music and fascination with the theater dovetailed with Nietzsche's belief in the restorative power of the musical drama (particularly that of the German composer **Richard Wagner**, 1813–1883). Nietzsche believed that true art must reconcile the two principles that defined ancient Greek culture: the *Apollonian,* which represented light, form, dreams, and the plastic arts; and the *Dionysian,* which depicted darkness, formlessness, intoxication, and music.

In music, unlike in painting or literature, there is no meaning separate from the work itself. A sound evokes emotion only at the moment of its execution. After a sound happens, it disappears. Nietzsche regards this as the core of tragedy and this was what Rothko sought to express in his paintings.

## Mythmakers

Rothko and Gottlieb were not alone in their discovery of mythology. In the late 1930s and early 1940s, a unique form of Surrealism was emerging in the United States that wedded the Surrealists' interest in dreams with Abstract Expressionism. A number of New York painters, including Pollock, **William Baziotes** (1912–

**BACKTRACK:
SURREALISM**

An international art movement that was centered in Paris in the 1920s. Of all the European artists in postwar New York, the Surrealists were the most influential. The Surrealists drew heavily on the psychoanalytical discoveries of **Sigmund Freud** (1856–1939). They recognized the unconscious as the main source for their art, which they created by merging dreams and imagination with everyday reality. The movement's leader was the French poet and critic **André Breton** (1896–1966), who published "The Surrealist Manifesto" in 1924 in Paris. The Surrealists invented two important techniques: **automatic drawing** (a spontaneous evocation of images from the subconscious of the artist) and **frottage** (a technique by which one takes a pencil and a piece of paper and makes a "rubbing" over a textured surface, similar to the rubbing of gravestone inscriptions or metal coins).

1963), and **Robert Motherwell** (1915–1991), had begun to reevaluate Surrealism and to experiment with automatism. These artists were particularly stimulated by the concept of *archetypes* and by the notion of the *collective unconscious* promulgated by the Swiss psychologist **Carl G. Jung** (1875–1961), once a disciple of Freud. Jung's psychology of the unconscious was based on his belief that the content of dreams originates from an area of the mind, shared by everyone, that he called the "collective unconscious." According to Jung, ancient myths were actually universal symbols or "archetypes" anchored deep within our unconscious minds. Many artists and famous people, including Jackson Pollock, underwent Jungian therapy in the late 1930s and early 1940s.

OPPOSITE
*Untitled.* c. 1941
Oil on canvas
18 x 24"
(45.8 x 61 cm)

**Sound Byte:**
> *Without monsters and gods, art cannot enact our drama.*
> —MARK ROTHKO, 1941

## Surpassing the Surrealists

Unlike the European Surrealists, who were more interested in dreams and hallucinations than in mythology, the New York painters, Rothko among them, were convinced that primitive myths and symbols continued to have meaning in the present. Their task, as artists, was to create new counterparts for those old myths. In a 1943 radio address, Rothko declared that ancient myths are real even today.

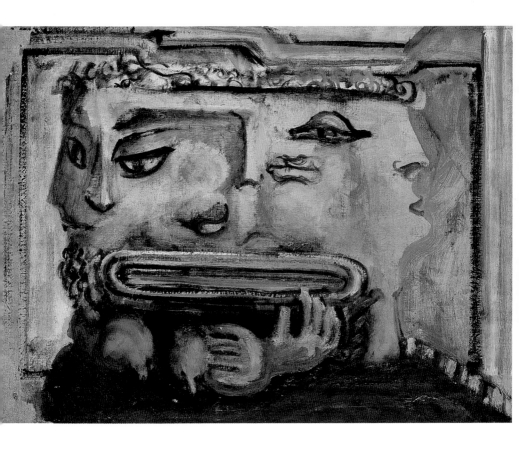

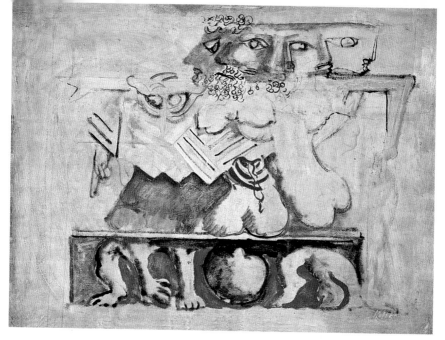

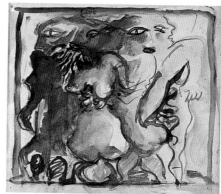

*Antigone* (above)
and study for
*Antigone* (right)

**Where:** The National Gallery of Art, Washington, D.C.

**When:** *Antigone*, begun around 1938, is Rothko's first "mythological" painting.

**What:** The title *Antigone* refers to the classical Greek drama of the same title written by the poet and philosopher, **Sophocles** (496–406 B.C.). Antigone was the daughter of Oedipus. In the story, after Oedipus, the blinded ruler of Thebes, left the city, his two sons, Eteocles and Polyneices, struggled to assume the succession. Eteocles prevailed, banishing his brother who returned with an army. Both died in the attack. When Thebes's new king, Antigone's uncle Creon, forbade the burial of the traitorous brother, Antigone, disobeying, symbolically buried her brother by sprinkling earth over his dead body. Condemned to death by Creon, she hanged herself. It is a classic example of the tragic collision between two irreconcilable powers of equal justification: the law of the state vs. the woman of conscience, which leads ultimately to the downfall of both. (Creon's son, Haemon, who was Antigone's lover, followed her by killing himself as well.)

Rothko expresses this tragic collision by painting two pairs of conjoined heads, two male and two female, gazing in opposite directions. The two female images depict Antigone and her sister Ismene; the two male, the bearded Creon and his son Haemon.

**What it teaches us:** The groups of overlapping figures and heads was a formal device that Rothko commonly used in the mythological paintings but also employed in non-mythological works. In *Antigone* and the paintings that followed, Rothko frequently divided the compositions into several horizontal bands, formally derived from his study of Etruscan or Roman sarcophagus reliefs.

*Antigone* was painted over an earlier painting, executed in his previous realistic style, a vertical composition of a female figure wearing a large hat. This reveals that Rothko's transition from the more representational New York paintings to the semi-abstract mythological works was more gradual than previously thought. Rothko continued to paint non-mythological works during the time he began his earliest mythological paintings such as *Antigone*.

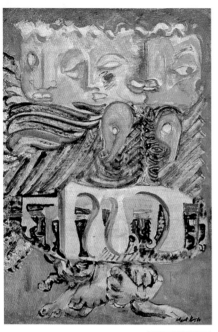

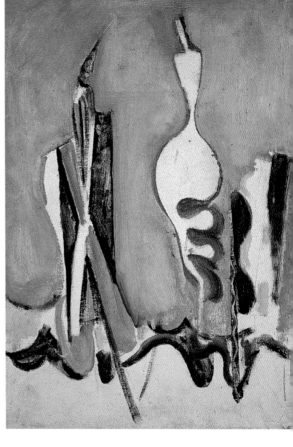

ABOVE
*The Omen of the Eagle.* 1942
Oil and graphite on canvas
25 3/4 x 17 3/4" (65.4 x 45.1 cm)

RIGHT
*Untitled.* 1943–44
Oil on canvas. 18 7/8 x 12 15/16"
(47.6 x 32.6 cm)

## The Jewell Affair

In 1943, the annual exhibition of the Federation of Modern Painters and Sculptors, a group with about sixty-eight members (Rothko was among its founders), was reviewed by *The New York Times* art critic **Edward Alden Jewell** (1888–1947). In his review, Jewell confessed his "befuddlement" over the exhibited works and he particularly singled out two "myth paintings," Rothko's *The Syrian Bull* and Gottlieb's *The Rape of Persephone* (both painted in 1943). Challenged by Jewell's provocation, the two artists (with the unacknowledged help of Barnett Newman) sent a manifesto in the form of a letter to Jewell, which ran in *The New York Times* one week later along with photographs of the two paintings. The statement began by "saluting" the honesty with which Jewell confessed to his perplexity over Rothko's and Gottlieb's mythological paintings, but it went on to say that "we do not intend to defend our pictures. We consider them clear statements." Rothko asserted that art was timeless and that no matter how archaic the symbols in his paintings might appear to be, they would continue to have full validity in the present.

The publication of their letter in the widely read Sunday art section of *The New York Times* created a public debate that continued for weeks in the pages of the newspaper. It is no surprise that, in 1946, Rothko referred to himself and to his fellow myth painters such as Pollock, Gottlieb, Baziotes, and Barnett Newman as a "small band of myth makers."

## Summary of Rothko's "mythological" period:

- His discovery of mythology was inspired by his reading of the ancient Greek tragedies and the German philosopher Friedrich Nietzsche.

- He believed that modern myths were needed and that it was the task of the artist to create them.

- While the myth paintings were not his greatest works, they represent a big step toward his later abstractions.

## Here comes Peggy

OPPOSITE PAGE
*Birth of Cephalopods*
1944. Oil on canvas
39 ½ x 53 ½"
(100.3 x 135.9 cm)

On October 20, 1942, Peggy Guggenheim's Art of this Century Gallery opened on the top floors of a former tailor shop at 30 West 57th Street. **Peggy (Marguerite) Guggenheim** (1898–1979), an avid art collector, was the granddaughter of a wealthy mining magnate and the niece of **Solomon R. Guggenheim** (1861–1949), the founder of New York's Guggenheim Museum (then called the Museum of Non-objective Art). When her father died on the *Titanic* in 1912, she inherited his fortune. She moved to Paris in 1930 and opened a gallery there in 1938. After she returned to the United States in 1941, she married the Surrealist painter Max Ernst.

Guggenheim gave one-person shows to many young American painters, including Pollock, Motherwell, and **Clyfford Still** (1904–1980). She exhibited Rothko's mythological paintings in 1945. While only a few paintings were sold, the show was a critical success, establishing the artist as an important painter of his generation. Yet Rothko was "keenly disappointed" when the critic from the *World Telegram*, whom he had spotted at the opening, failed to review the show. He made a futile attempt to persuade her to write about his show, saying, in a letter, that should she find space for a review in the following weeks, "it would make me very happy." Needless to say, "happiness" wasn't exactly a frequent emotion in Rothko's life.

## Divorce, American-style

In 1943, after years of strong-headed clashes, the artist and his wife, Edith Sachar, split up for a second and final time. They drummed up a spurious story of infidelity to satisfy the prudish divorce laws of the times.

An example of the artist's signature

*Untitled*
1945–46
Watercolor,
black ink, and
graphite on
wove paper sheet
22 1/2 x 15 7/16"
(57.15 x 39.21 cm)

Mary Alice "Mell" Beistle in 1940,
four years before her marriage to Rothko

After his divorce, Rothko wrote to his sister, Sonia: "Here, at the age of forty, I am on the brink of a new life. It is both exciting and sad, but I regret nothing about it." Two years later, he married **Mary Alice "Mell" Beistle** (1922–1970), a commercial artist and a children's book illustrator, who became the mother of his two children, Kate and Christopher. Mell was fond of telling friends that she got Rothko to propose marriage to her by sitting on his lap.

## Betty and her boys

In 1944, Peggy Guggenheim introduced Rothko to **Betty Parsons** (1900–1982). Parsons was born to a wealthy, conservative New York family and, like Peggy Guggenheim, lived in Paris, where she studied sculpture and met many avant-garde artists and writers. A divorcée, she sold her wedding ring and returned to New York in the late 1930s to be an artist.

Before long, she was hired by an Old Masters' dealer to start a Modern art gallery. It was during this time that she met Rothko and subsequently arranged for a show of his watercolors.

In 1946, when the owner of the gallery decided to leave the Modern art business, Parsons took over the lease on his space at 15 East 57th Street. Borrowing $1,000 from each of five friends, she opened the Betty Parsons Gallery in the fall of 1946. Rothko, Newman, and Still all signed on. She would call the three artists—along with Jackson Pollock, who joined later—her "Four Horsemen of the Apocalypse." Parsons became Rothko's first dealer, giving him a total of five annual one-person shows.

**Sound Byte:**

*I'd like to have money; I'm not crazy like van Gogh.*
—MARK ROTHKO, 1951

Parson's gallery was *the* place to see American vanguard art in New York. It also became a place for artists to meet and exchange ideas. The artists were able to have their own shows but sales were modest. In 1952, when Pollock left Parsons for the more financially successful Sidney Janis Gallery across the street, the others followed. In the spring of 1954, Rothko, the last to leave Parsons, signed on as well.

*No. 18.* 1946
Oil on canvas
61 x 43 ¼"
(155 x 109.8 cm)

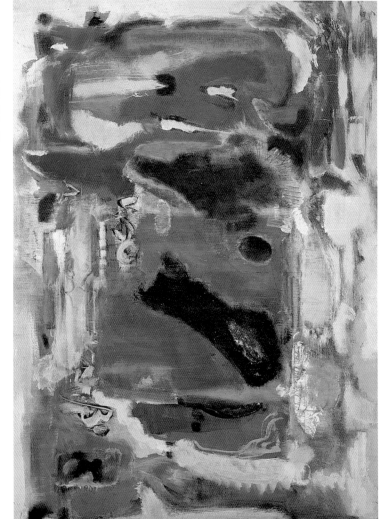

## Breaking loose

In 1946, Rothko began a startlingly new body of work in which he broke free of the restraints he had felt in painting the human figure.

Dispensing with the various elements used in the Surrealist works, he advanced a new treatment of space and color in the form of large abstract canvases that he called *Multiforms*. These works consisted of large and small diaphanous color patches that lacked the solidity and definition of his earlier paintings.

It was as though Rothko had poured paint thinner onto one of his myth paintings, thereby dissolving its semi-abstract elements into individual, abstract blotches of color. With time, Rothko would reduce these color blotches more and more—to the point where, in his mature phase, he would paint only two or three floating, monochrome rectangles that allowed him to explore endlessly the relationship of the rectangles to the scale of the canvas.

While painting, Rothko frequently turned the canvas on its side or its top in order to reduce the possibility that recognizable images would accidentally appear. Most of the works would be identified only by number and year.

THIS PAGE
*No. 2.* 1947
Oil on canvas
57 1/4 x 44 1/4"
(145.4 x 112.24 cm)

OPPOSITE PAGE
*Untitled.* 1948
Oil on canvas
49 3/4 x 44"
(126.4 x 111.8 cm)

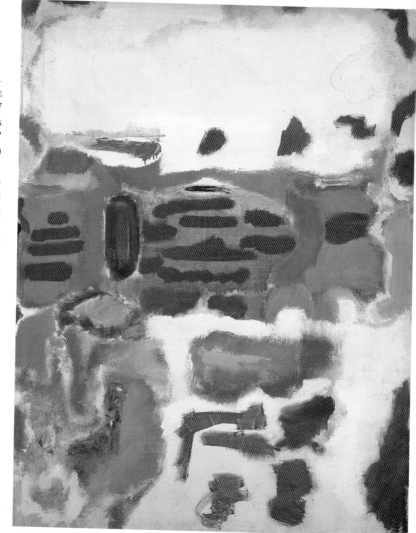

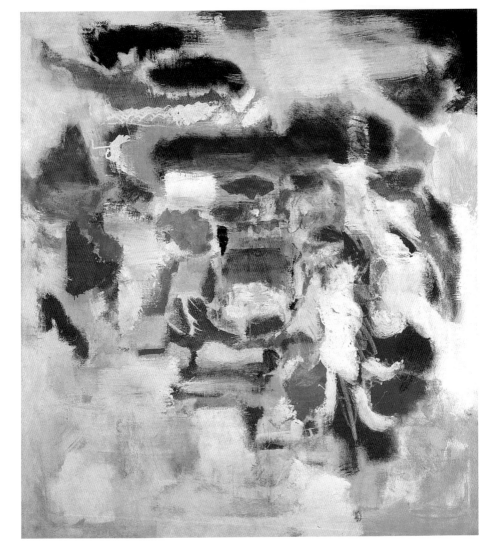

## Variations on a stylistic theme

OPPOSITE
*No. 9.* 1948
Oil and mixed
media on canvas
53 x 46 ⅝"
(134.7 x 118.4 cm)

Again, Rothko was not alone. The period between 1947 and 1950 was one of bold experimentation in American art. In 1947, a number of New York artists began to define a new language of abstraction in a style that soon became known as **Abstract Expressionism** ("AbEx"), or the New York School of Abstract Expressionism. That same year, Jackson Pollock began his famous series of *drip* paintings by splattering paint with a paintbrush, directly from the can, onto outstretched rolls of canvas that he would lay on the floor of his studio in his barn at The Springs, Long Island.

**Sound Byte:**

*I think of my pictures as dramas; the shapes in the pictures as performers.*
—MARK ROTHKO, 1947

On January 29, 1948, the day of his forty-third birthday, Barnett Newman attached a strip of tape down the center of a small, dark-red painting. He then painted the tape a lighter red, and thus created his first "zip" painting. This is how he arrived suddenly and spontaneously at his signature style: canvases that featured one or several thin vertical bands of color applied on top of monochrome surfaces.

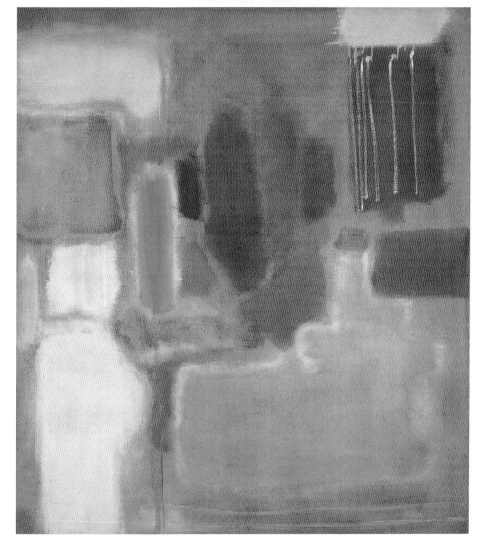

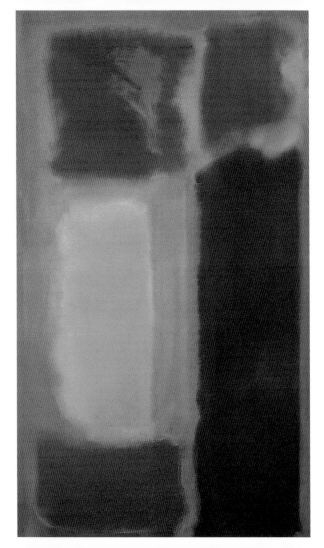

## From Avery to Matisse

In 1949, when Matisse's celebrated painting *Red Studio* (1911) was permanently installed at the Museum of Modern Art in New York, Rothko visited the museum each day for months in order to view the great work of art. He likened its enveloping sense of color to music,

OPPOSITE PAGE
*No. 17* [or] *No. 15*
1949. Oil on canvas
51 7/8 x 29 1/8"
(131.8 x 74 cm)

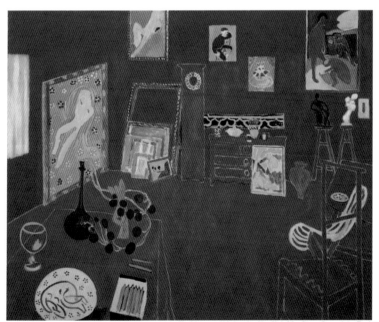

LEFT
Henri Matisse
*The Red Studio*
Issy-les-
Moulineaux. 1911
Oil on canvas
71 1/4 x 72 1/4"
(180.98 x 183.52 cm)

The Museum of Modern Art, New York. Mrs. Simon Guggenheim Fund

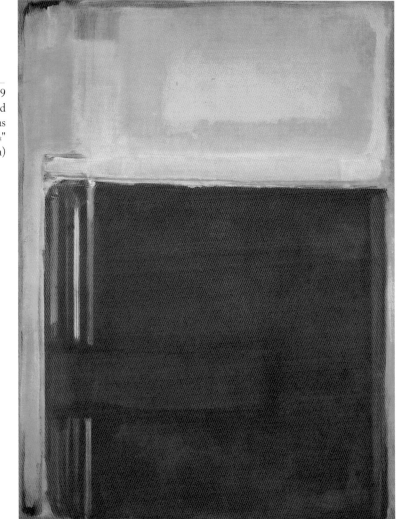

*No. 8.* 1949
Oil and mixed
media on canvas
89 7/8 x 65 7/8"
(228.3 x 167.3 cm)

and years later told his second wife, Mell, that he owed all of his achievements in art to Matisse—and, in particular, to Matisse's *Red Studio*.

By the end of 1949, Rothko had reduced the number of rectangles in his paintings to two or three, expanding their size, and creating the distinctly recognizable style that would remain with him until the end of his life.

In the 1960s, he would once again refine his signature use of color. Where he formerly had placed contrasting hues with similar values side by side, he would then begin to create works that were increasingly based on a single color contrasted against a darker or lighter companion color.

Consuelo Kanaga

Mark Rothko at the "Icehouse," Yorktown Heights, New York. c. 1949

---

**FYI: A loving tribute**—When Matisse died in 1954, Rothko painted his *Homage to Matisse*, a tall, narrow canvas covered in hues of orange-yellow, red, and orange. These hues surrounded a highly saturated blue rectangle that was reminiscent of the stained-glass windows Matisse painted during his later years.

**Sound Byte:**

*At first Rothko's paintings seem to work by color alone—wild contrasts of green, orange, yellow, and scarlet create a savage rhetorical impact. But under this extremely emotional level is a strength of composition.*

—THOMAS HESS, art critic, 1949

## Abstract painter against his will

It should be remembered, however, that Rothko never considered himself an abstract painter, not even during his mature phase. He regarded color primarily as a carrier for emotion. By limiting his shapes and colors, he intended to increase, not reduce, emotion in his paintings. He chose abstraction as a means of expressing the human condition in all its complexities. He was an abstract painter against his will.

## The artist's subjects

In 1948, Rothko joined his fellow painters Motherwell, Baziotes, and Still, along with the sculptor David Hare, in briefly founding an art school at 35 East 8th Street in Greenwich Village. They called it "The Subjects of the Artist School," a name suggested by Barnett Newman. Rothko liked it because it emphasized his point that their paintings did

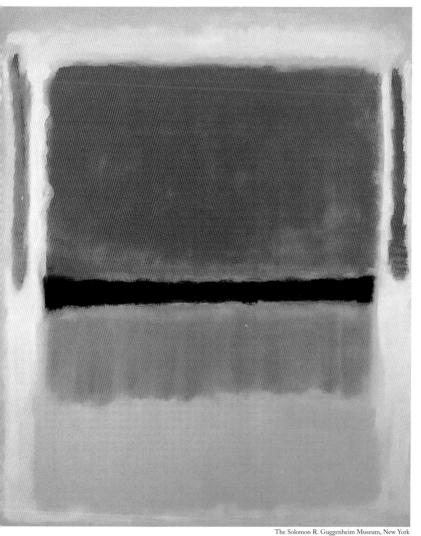

*Violet, Black, Orange, Yellow on White and Red*
1949. 81 x 66"
(205.75 x 167.64 cm)

The Solomon R. Guggenheim Museum, New York

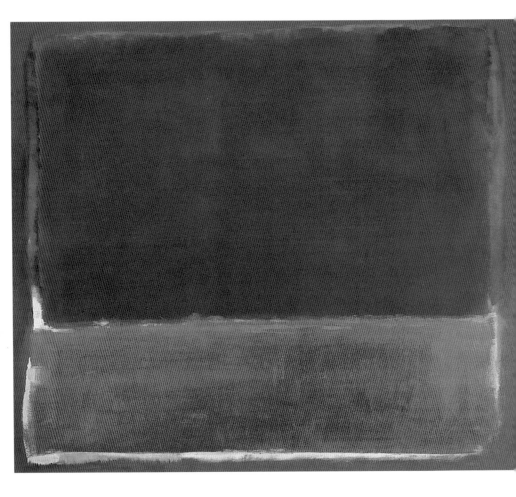

have subjects, even though they were "nonrepresentational." All were free to teach whatever subjects they chose. Even though the school closed in April 1950—with a three-day symposium, "Modern Artists in America"—in its short existence it had created a lively forum for debate and some publicity for the artists.

*Untitled.* 1950
Oil on canvas
43 ⅛ x 49 ⅝"
(109.6 x 126.1 cm)

## Growing silent

As his paintings became entirely abstract, Rothko grew increasingly reluctant to talk about his work. In the summer of 1950, when asked for statements by several art journals, he responded with, "I have nothing to say. . . . The self-statement business has become a fad this season."

**Sound Byte:**
> *I film nothing and you paint nothing.*
> —MICHELANGELO ANTONIONI, Italian filmmaker,
> writing to Rothko in the late 1960s

He also discontinued the practice of giving narrative titles to his new paintings. Today, his abstract paintings are referred to either by the number and year he assigned to them or by descriptive titles ("Orange, Red, Yellow," "Blue and Gray") that were either given by the artist or posthumously assigned by dealers and art historians to the many works Rothko had left both unnumbered and untitled.

**Sound Byte:**
*Some artists want to tell all like at a confessional. I as a craftsman prefer to tell little.*

—MARK ROTHKO, 1958

## The *Irascibles*

OPPOSITE
*Untitled.* 1951
Oil on canvas
44 ¼ x 37 ⅜"
(112.4 x 94.9 cm)

In 1950, Rothko participated in an "open letter" to the Metropolitan Museum of Art, which was signed by eighteen artists, including Willem de Kooning, Barnett Newman, Ad Reinhardt, and Jackson Pollock. In their letter, the artists protested the conservative jury for the Metropolitan Museum of Art's national contemporary art competition. The letter produced headlines in both *The New York Times* and *The New York Herald Tribune,* and led to a photo story in *Life* magazine on the "Irascible Eighteen." The article was illustrated with a now-famous group picture taken by *Life* photographer **Nina Leen** (b. 1909), which the art historian **Irving Sandler** (b. 1925) later defined as the quintessential image that forever represented the triumph of American painting. Leen allowed the artists to position themselves for her photograph. Rothko placed himself in a prominent position in the front row at the right corner of a triangle formed by himself, Barnett Newman, and the painter **Theodoros Stamos** (1922–1997).

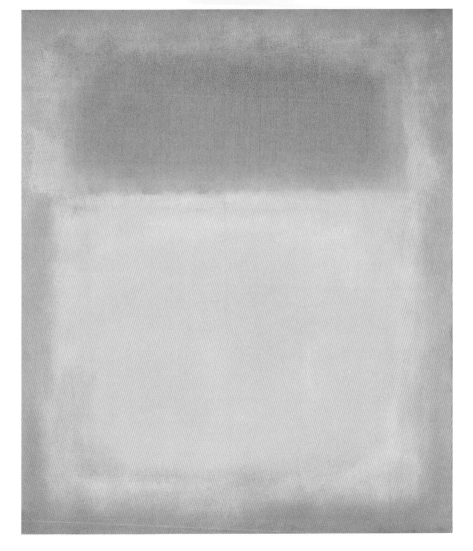

## HOW ROTHKO DID IT

By the 1950s, Rothko had not only found his mature style, but had also established the technique for the paintings that he would execute in the final phase of his career.

Here it is, step by step:

- Like Pollock, Rothko often began with a roll of unprimed, raw canvas, the width of which defined the width of the painting, which he then stretched over wooden stretchers.

- A wash of powdered pigments mixed with glue was applied to the entire surface of the canvas, in effect dyeing the pigments into the canvas. This became the background for his floating rectangles of color (Rothko referred to them as "objects"). The canvas often continued past the edges of the stretcher bars to cover the tacked margins.

- Rothko's objects were painted with glazes of mixed paint to which, beginning in 1950, Rothko added powdered pigments and whole eggs. He lightly brushed the paint out from the center of the canvas or worked inward from a designated frame at the edges.

- The glazes of paint were often thinned with a solvent such as turpentine, diluting them so much that light penetrated the surfaces of his works, endowing them with their characteristic emanating glow.

- Rothko would sit, sometimes for hours or days, in front of the canvas, considering the next color to be used or contemplating the shape of a particular area. The actual painting, however, was done very rapidly, in the manner of the automatic drawing technique that he had adopted from the Surrealists.

From 1949 to 1956, Rothko worked almost exclusively with oil paint on vertical canvases ranging from 18" square to more than 10' square, mostly painting intensely brilliant hues of yellow, orange, and red. By 1957 his paintings had grown darker, featuring deep reds, earthy browns, and black. This trend toward less transparency in an overall somber mood would continue, with some exceptions, until his death.

**Sound Byte:**

*He was a man who expressed his feelings in his work. That's the key.*

—DORE ASHTON, art historian, 1998

## Recognition and prosperity

The mid-1950s were successful years for Rothko, although it was not until nearly 1960 that he could make a living solely as an artist. *Fortune Magazine* announced that "the art market is boiling with an activity never before known." In 1957, Sidney Janis Gallery, which Rothko had joined three years earlier, was selling twice as many pictures as in the year before, and in 1959 Rothko's income from sales had tripled from $20,000 to $60,000.

> *FYI:* **No frames, please**—Rothko adamantly insisted on keeping his paintings unframed, with their edges exposed. The painter **Robert Ryman** (b. 1930), who worked as a guard at MoMA from 1953 until 1961, recalls that the Modern decided to put a box frame on one of Rothko's paintings, and although the frame did not touch the edges of the painting, a greatly upset Rothko insisted that the frame be removed.

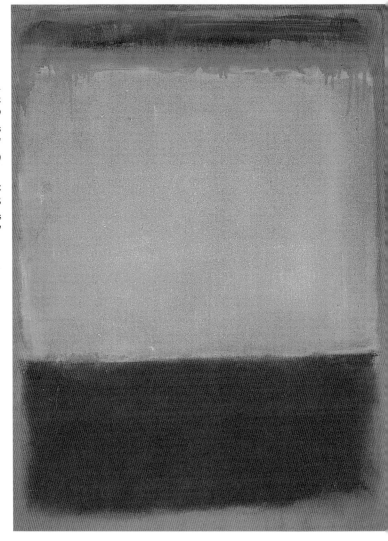

THIS PAGE
*Untitled.* c. 1949
Oil on canvas
32 x 23 ⅝"
(81.28 x 59.91 cm)

OPPOSITE PAGE
*Untitled.* 1953
Mixed media on canvas
76 ¼ x 67 ¼"

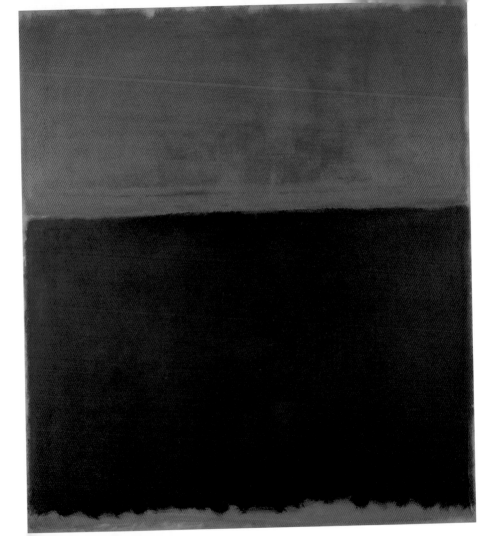

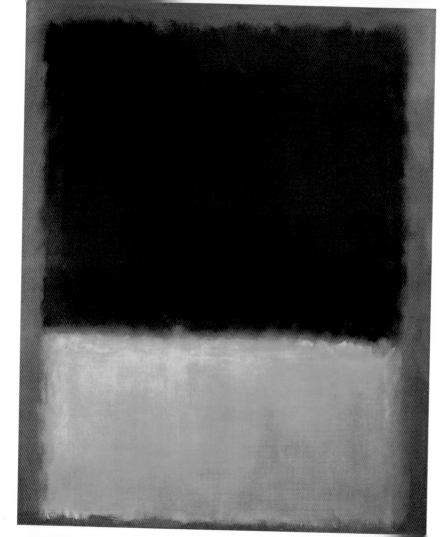

In 1958, the Seagram Company commissioned Rothko to paint a series of murals for the planned Four Seasons Restaurant in their new American headquarters on Park Avenue. Seagram's was the world's largest producer and distributor of distilled spirits and had already purchased Rothko's *Brown and Black in Reds* (1958) for its art collection. Rothko's assignment was to create a series of paintings for the smaller of the restaurant's two dining rooms, and for this he would receive $35,000, with a $7,000 down payment and the rest paid out in equal installments during a four-year period.

OPPOSITE
*Untitled.* 1954
Oil on canvas
68 ½ x 84 ¼"
(174 x 214 cm)

## . . . and giving it back

While he was originally enthusiastic about the project, he soon began to have mixed feelings about his paintings hanging above the heads of wealthy diners and he became increasingly distraught at the prospect. In a letter to a friend, the painter Robert Motherwell, he confessed that the Seagram commission "has steamed up enough anger in me to imbue the pictures with unbearable bite." On a boat trip from New York to Naples, Italy—which he paid for, incidentally, with the money he had received from Seagram—Rothko mentioned to a casual acquaintance whom he had met on board that he was to paint a series of canvases "for the walls of the most exclusive room in a very expensive restaurant . . . where the richest bastards in New York will come to

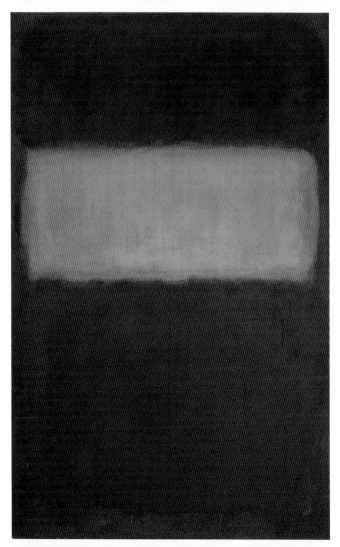

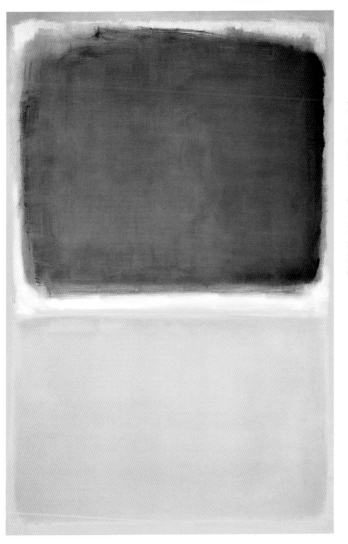

THIS PAGE
*Untitled.* 1954
Oil on canvas
67 ⅝ x 44 ⅝"
(171.75 x 13.33 cm)

OPPOSITE PAGE
*Untitled (Number 7)*
1954. Mixed
media canvas
70 x 44"
(177.8 x 111.8 cm)

feed and show off." He confided that he had accepted the commission "with strictly malicious intentions" and that he hoped "to ruin the appetite of every son of a bitch who ever eats in that room."

When the Four Seasons Restaurant opened in July 1959, Rothko went there to eat with his wife, Mell, but returned home in a rage. Offended by the pricey menu and the unabashed wealth displayed by the diners, and clearly remembering the poverty and hardships of his childhood (the little boy from Russia was still inside him), he withdrew from the project and returned all the money he had received. During the two years he worked on the commission, he had already produced about forty panels from which the final selection would have been made.

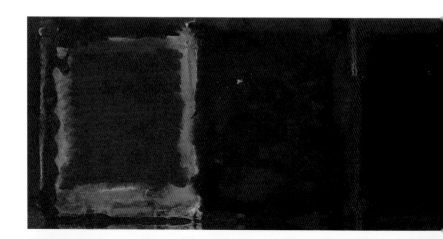

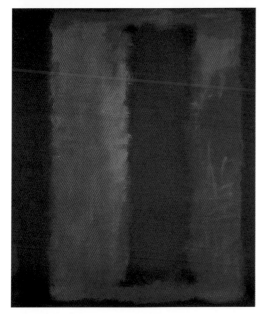

LEFT
*Untitled (Seagram mural sketch)*
1959. Oil and acrylic on canvas
72 x 60 1/8" (183.5 x 152.7 cm)

BELOW
*Untitled.* 1958–59
Gouache and watercolor on red
construction paper. 4 3/4 x 20 1/8"
(12.07 x 51.12 cm)

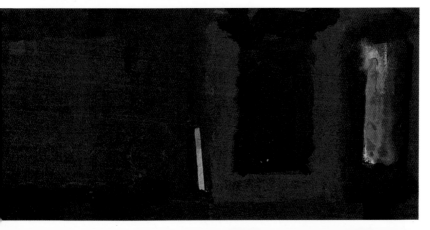

## Rothko's biggest triumph

OPPOSITE
*No. 1.* 1961
Oil and acrylic
on canvas
101 7/8 x 89 5/8"
(258.8 x 227.6 cm)

The 1961 retrospective at MoMA, on view there for two months, was the museum's first one-person show of a living artist of Rothko's generation. This was a personal triumph for Rothko. The exhibition later traveled to the major art capitals of Europe—London, Amsterdam, Brussels, Basel, Rome, and Paris—a tour that most artists could only dream about.

Rothko visited the New York show almost daily and tried unsuccessfully to have the exhibition extended beyond its closing date of March 12 because the most important reviews would not appear until later that month. He became involved in many of the details of the installation: the **color of the gallery walls** ("off-white with umber and warmed by a little red"); the **positioning of his paintings on the wall** (Rothko requested that the large ones be hung near the floor, except for the Seagram murals, which were to be hung higher than usual, as he had originally intended them for the restaurant); and the **lighting** ("it should not be too strong"). Ideally, Rothko would have preferred that his paintings be hung in daylight, since this would allow the colors to radiate more softly.

Even though he was elated during the opening of the show, the next morning he was filled with despair: "Everyone can see what a fraud I am."

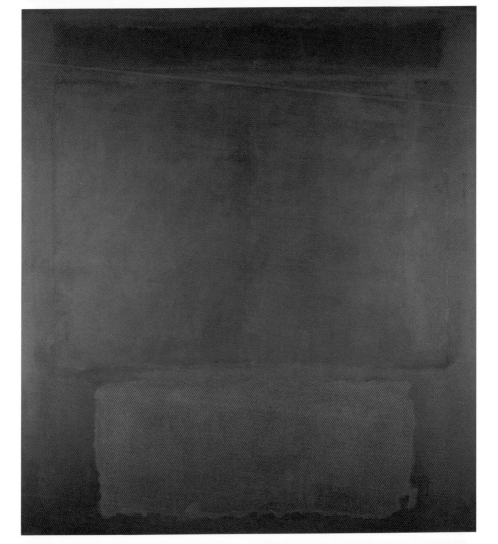

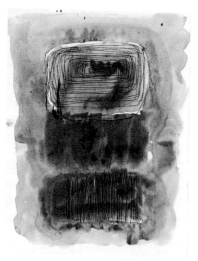

*Untitled.* 1961
Pen and ink and wash on wove paper
11 x 8 ⁹⁄₁₆" (28 x 21.7 cm)

## Tormenting curators and dealers

Working with Rothko proved to be a challenge for the Modern's curators. Two days before the opening, the artist replaced six of the works selected by the museum with seven new ones.

Rothko is described by most people who knew him as a charming but demanding man—one whose genuine tenderness and warmth were sometimes colored by impatience and anger. Throughout his life, Rothko maintained firm control of his work and was selective in terms of where his pictures would be placed and to whom they would be sold:

- When President John F. Kennedy's sister went to Rothko's studio in the early 1960s to purchase a painting, he refused to let her take anything to her apartment to see if she was happy with the work once it was in her home, prior to purchasing it. This form of "purchasing on approval" is a common courtesy that galleries often extend to their most important clients, but Rothko would have nothing to do with it.

- He would frequently refuse to make an exchange of a painting for a customer, preferring instead to refund the customer's money.

- Rothko's strong ethical principles were more important to him than personal financial gain. In 1958, on learning that one of his paintings

had won the Guggenheim Museum's National Award Competition (it had been submitted without Rothko's knowledge by his dealer, Sidney Janis), Rothko refused the award and returned the $1,000 check because he objected to the idea of competition among artists.

## . . . and controlling critics

In 1957, the painter **Elaine de Kooning** (1920–1989), a regular contributor to *ARTnews* magazine, wrote a piece about Rothko and his fellow painter **Franz Kline** (1910–1962). On the night before her deadline, she made the mistake of showing the article to Rothko. He agreed with what she had said about Kline, but hated the part about himself and insisted that she rewrite the article with him seated at her side. Together, they went to her apartment, and as she finished each page, she handed it to him and he made corrections, then handed the page back to her. Not only did Rothko want complete control over his paintings and their presentation—a desire that most artists would understand and support—but he also yearned to control what was said about his work.

## What to remember about Rothko's mature style:

- His 1947 *Multiforms* and subsequent works represented the most innovative use of color since Matisse.
- Rothko regarded his floating rectangles of color as *objects*, not as *actions* or *color fields*.
- He regarded his works as vehicles for expressing emotion, not as abstract paintings that lacked content.

**FYI: The un-Modern MoMA**—In 1950, the director of MoMA, **Alfred Barr** (1902–1981), wanted a Rothko painting for the museum. However, he knew that the acquisitions committee would never approve this purchase, so he asked the architect **Philip Johnson** (b. 1906) to buy one and donate it to the museum. Johnson complied, buying *Number 10, 1950*, for $1,250. Nonetheless, it still took two years and the indignant resignation of a MoMA trustee before the museum board would approve the donation.

## Pop vs. AbEx

In 1962, Sidney Janis presented "The New Realists," an exhibition of works by the artists **Jim Dine** (b. 1935), **Robert Indiana** (b. 1928), **Roy Lichtenstein** (1923–1997), **Claes Oldenburg** (b. 1929), and **Andy Warhol** (1930–1987), whose representational images were influenced by advertising and popular culture. Because of this, they came to be known as "Pop" artists. After the show, an irritated Rothko left the gallery in protest with his equally disenchanted friends Adolph Gottlieb, Phillip Guston, and Robert Motherwell. Clearly, they were not pleased by what they had seen at Janis's gallery.

On October 13, 1965, a major collector sold thirteen Abstract Expressionist paintings, including Rothko's *Number 22 (Reds)*, at a highly pub-

licized auction that generated headline speculation about the end of the movement. ("Is Abstract Expressionism Passé?")

## Courted by presidents . . .

Rothko appears to have been a favorite artist of the Kennedy Administration. In January 1961 he was invited to the inaugural celebration for **President John F. Kennedy** (1917–1963) in Washington, D.C. He attended the event with the painter Franz Kline, wearing a rented dinner jacket. In May 1962, he was invited back to the White House for a dinner in honor of the French cultural minister, **André Malraux** (1901–1976). There, he dined among other guests from America's cultural elite, including the playwrights **Arthur Miller** (b. 1915) and **Tennessee Williams** (1911–1983), choreographer **George Balanchine** (1904–1983), conductor/composer **Leonard Bernstein** (1918–1990), and fellow painter **Andrew Wyeth** (b. 1917).

The dinner was held to celebrate the arrival in America of the *Mona Lisa*, the masterpiece by **Leonardo da Vinci** (1452–1519). The painting, which hangs in the Louvre in Paris, is arguably the most famous work of art ever made and had been sent to America as part of an exhibition that would tour throughout the country. Seated next to Lyndon B. and

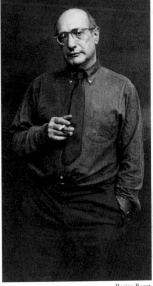

Regine Bogat

Mark Rothko on his 57th birthday (1960)

Ladybird Johnson, the Rothkos listened to President Kennedy quip jokingly, during his toast, that the White House was "becoming a sort of eating place for artists." Then he smiled and added, "But they never ask *us* out."

In 1965, Rothko returned to Washington for the inaugural events of **President Lyndon B. Johnson** (1908–1973), but this time he rode in the company of a group of illustrious artists and performers on a bus marked "Cultural Leaders." As in his previous visits to the White House, he took great pleasure in this excursion to the nation's capital.

## . . . and scoundrels

In November 1963, the Marlborough-Gerson Gallery opened in New York City in a 12,000-square-foot space on the sixth floor of the Fuller Building at 57th Street and Madison Avenue. It was run by the Austrian-born **Frank Lloyd** (1910–1998), who had earlier settled in London to open the Marlborough Gallery.

Unlike other galleries, Marlborough was a "full-service" business. It took a commission of 50 percent on sales rather than the then-traditional one third. In exchange for this extraordinary fee, the gallery offered its artists a full array of services that included legal, accounting, and real-estate advice. Prior to the gallery's opening in New York, Lloyd invited three of the most sought-after New York artists—Mark Rothko, Willem de Kooning, and **Philip Guston** (1913–1980)—to dinner at

his suite in the posh St. Regis Hotel. He easily won over the artists with his old-world charm and seductive offer to do anything the artists desired, whenever they wished it. In response to Rothko's probing request that Lloyd arrange a one-man show of the artist's works in his hometown of Dvinsk, Russia, Lloyd replied that he would arrange for such a show to take place. Guston and Rothko had recently left the Sidney Janis Gallery and, duly impressed by the promises made by Lloyd, decided to join Marlborough. (As one can imagine, however, Rothko's show in Dvinsk never materialized.)

## Never sign a contract without a lawyer

Rothko's first contract with Marlborough gave the gallery the exclusive right to sell, reproduce, and exhibit his paintings outside the United States for five years. The gallery also purchased fifteen works outright, for a total of $148,000, with payment to be made in four annual installments. Further, Rothko agreed not to show with any other dealer in the United States for one year. This marked the beginning of a business relationship that would become, after Rothko's suicide in 1970, one of the greatest art scandals of the 20th century. In 1969, a year before his death, Rothko signed a second, highly questionable contract with Marlborough that granted the gallery the right to be Rothko's exclusive dealer for the next eight years. The same contract transferred eighty-seven paintings to Marlborough for a total sum of $1,050,000, which was to be paid over a period of ten years. (This term was later

extended to fourteen years.) At the time, Rothko was sixty-six years old and had serious health problems. He did not have a lawyer, in part because he had developed a lifelong distrust of the legal process.

## Going to Harvard

In the early 1960s, Rothko agreed to paint and donate murals for the dining hall of the Holyoke Center, a new administration building at Harvard University. When the administration suggested a single mural-scale painting, Rothko replied that he would rather create a meditative environment composed of five panels, each 8 feet high. He wanted one triptych to be hung on the recessed west wall and to have single panels installed on either side of the double doorway, thus creating a dynamic interaction among them.

Building on forms he had developed for the Seagram murals (which had taken twenty months to complete), Rothko required only nine months to create the Harvard murals. He painted six panels, five of which were to be installed in the dining room.

## Drinking with a president

On October 24, 1962, Harvard's president, **Nathan Pusey** (1953–1971), paid a visit to Rothko's New York studio to evaluate and render final approval of Rothko's murals for Harvard, as the university had a contractual right of refusal. When Pusey arrived, however, he found no

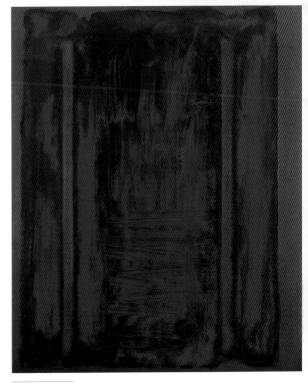

ABOVE RIGHT
*Untitled (Harvard Mural sketch)*. 1962
Oil, acrylic, and mixed media on canvas. 69 1/8 x 56 1/8"
(175.6 x 142.6 cm)

ABOVE LEFT
*Untitled (Sketch for Harvard Mural)*. c. 1961
Pen and ink, and watercolor with graphite annotation
on wove paper. 11 x 8 9/16" (28 x 21.7 cm)

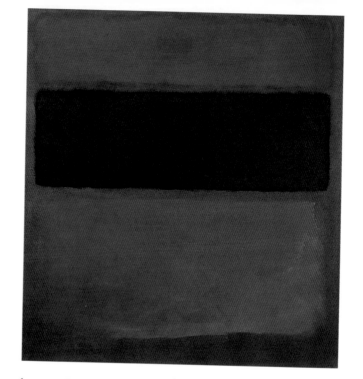

*Untitled (Brown, Black, and Sienna on Dark Wine).* 1963
Oil on canvas
69 x 64"
(175.25 x 162.50 cm)

one home at Rothko's First Avenue studio. After waiting for a while in front of the building, he noticed a scraggly old man approaching him, dressed in work clothes and carrying a paint bucket. The man introduced himself as Mark Rothko.

Rothko led Pusey up a flight of stairs to the studio, poured them both a drink of whiskey in paint-stained glasses, and sat him down in front of

**FYI:** Unfortunately, the Harvard murals have suffered grave deterioration and damage over the years. Experts have variously attributed this to years of exposure to sunlight, to Rothko's practice of layering oil paint with egg whites, and to his use of a new synthetic pigment, popular in the 1950s and 1960s, known as *lythol red*. The paintings are now permanently stored in the basement of the Fogg Museum at Harvard.

what Pusey later remembered as five "eggplant-colored canvases." When Rothko asked what he thought of his canvases, Pusey—a novice to the subject of Modern art—replied hesitantly that he found the paintings "rather sad." Bingo! He had said the right thing. Rothko approvingly engaged him in a long conversation in which he explained the paintings as an evocation of Christ's suffering. Intrigued by Rothko's spiritualism, Pusey returned to Harvard with a recommendation that the college accept the paintings. The murals were installed in January 1963.

## A commission in Houston

In early 1965, Rothko signed a contract to produce a set of murals for a Roman Catholic chapel to be built in Houston, Texas, by the Paris-born **John de Menil** (1904–1973) and his wife, **Dominique de Menil** (1908–1998), prominent Houston art patrons. The chapel, located in the Montrose District of Houston near St. Thomas University, was dedicated on February 28, 1971, almost one year after Mark Rothko's suicide.

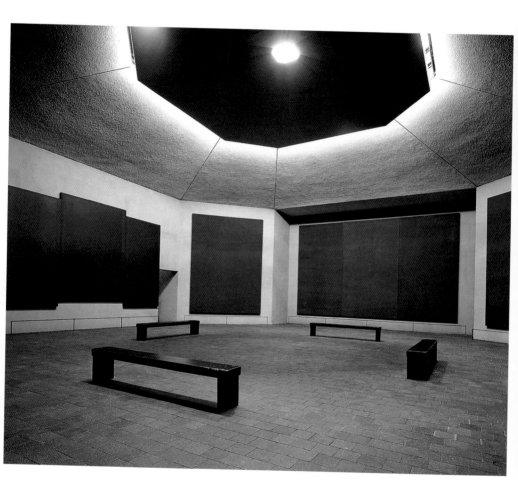

## ROTHKO CHAPEL MURALS
### (1964–67)

The Rothko Chapel was supposed to have been designed by Philip Johnson, but it quickly turned into a collaboration between Johnson and Rothko, with the latter retaining the right to approve the architectural details.

Rothko had proposed the existing octagonal space, inspired by the Byzantine church of Santa Maria Assunta on the island of Torcello, near Venice, rather than the square design envisioned by Johnson.

At first the architect accepted Rothko's input and worked on the project for three years. But soon the inevitable clash of geniuses turned their collaboration sour.

Johnson finally resigned after a dispute with Rothko over the chapel's lighting and many years later Johnson continued to insist that his ideas were the right ones. The building was completed by a Houston architectural firm, which followed Rothko's specifications to his satisfaction.

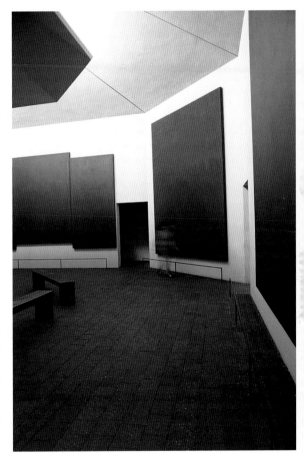

Its interior space, graced by the presence of fourteen monumental maroon-and-black canvases painted with a severely reduced palette, remains one of the most important artistic commissions funded by private citizens in the 20<sup>th</sup> century. Not since the Italian Renaissance artist **Michelangelo** (1475–1564) designed the Medici Chapel in Florence has an artist created such solemn visual unity between architecture and art. During the time Rothko was working on the murals, the chapel's Catholic affiliation was dropped. Today, the chapel is used and visited by people of all faiths.

**Sound Byte:**
*The magnitude, on every level of experience and meaning, of the task in which you have involved me, exceeds all my preconceptions. And it is teaching me to extend myself beyond what I thought was possible for me. For this I thank you.*

—MARK ROTHKO, writing to John
and Dominique de Menil, 1965

## How Rothko painted the Houston murals:

- He began with about eighteen unprimed cotton duck canvases that two of his assistants, working under his guidance, primed with highly thinned maroon oil paint. Due to his age (he was 62 at the beginning of the project), Rothko removed himself from most of the physical labor, directing his assistants in the manner of a Renaissance

master. He typically arrived at 6:00 AM, three hours earlier than his assistants, who worked only two or three hours per day. They brushed the paint in a fast, continuous motion from one end of the canvas to the other. Half of the chapel panels—the apse triptych and the four angled-wall paintings—were monochromes (i.e., one color only). They were the first monochromes that Rothko had ever "painted."

■ On each of the remaining canvases—the triptychs on the two side walls and the single rear-wall painting—Rothko painted one large, flat, black rectangle. After using masking tape to mark the dimensions of the rectangles on the primed canvases, he had his assistants fill them in with black charcoal. He would spend months just looking at them. Occasionally, he would change the size of the rectangles. When he arrived at the final dimensions for the forms, he brought out new canvases, with the background color already applied, and painstakingly transferred the rectangles with masking tape from the original canvas to the new one, using masking tape to hold them in place. He then filled in the interior forms with flat black paint. These black areas are the only parts that Rothko painted

**FYI: Doing it his way**—Rothko's murals are not "murals" in the strictest sense. They were always painted on canvas in his studio, not directly on the walls of the site for which they were intended.

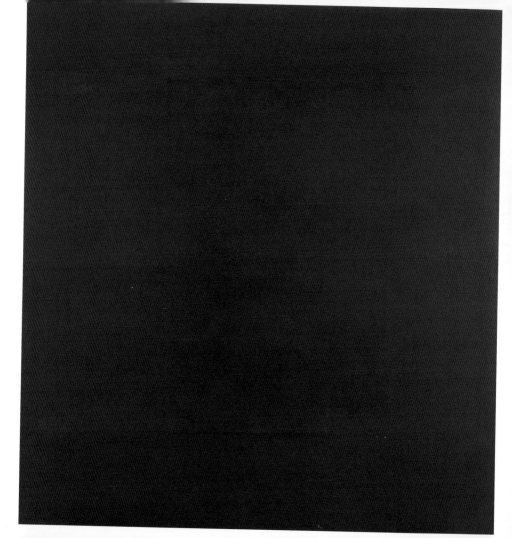

himself. He never visited the actual site and did not live to see the works installed in the chapel. He had stored eighteen paintings—the fourteen that are now installed in the chapel, plus four alternates. As was his custom, he had planned to make his final decision only at the time of the installation.

OPPOSITE
*No. 5.* 1964
Oil, acrylic, and mixed media on canvas. 81 ⅛ x 77 ¼" (206.2 x 195.7 cm)

**Sound Byte:**
*A picture lives by companionship, expanding and quickening in the eyes of the sensitive observer. It dies by the same token. It is therefore a risky and unfeeling act to send it out into the world.*
—MARK ROTHKO, 1947

## Escaping death

On April 20, 1968, the 64-year-old Rothko suffered a life-threatening aortic aneurysm caused by hypertension. Prior to this episode, he had been diagnosed with arteriosclerosis and showed early signs of cirrhosis. For years, he had suffered from bouts of depression and had been taking various medications for high blood pressure and depression. His physicians had asked him to stop smoking and drinking, but he chose to ignore them.

Incapacitated for weeks, he spent the summer of 1968 recuperating in Provincetown, Massachusetts. His doctor had instructed him not to work on any paintings that were larger than forty inches, so he painted small

OPPOSITE
*Untitled.* 1967
Acrylic on paper
mounted on
hardboard panel
23 7/8 x 18 7/8"
(60.6 x 47.9 cm)

works on paper, but he did this with great energy, moving his whole body rather than his wrist. He created the paintings with acrylic paint instead of oils, and would continue to use this paint for the rest of his life.

Cutting the paper from rolls, he dampened, stretched, and affixed it with staples or tape to wooden walls or plywood easels. He often worked on fifteen different works of art at once—some colorful, others dark. The tape he used to attach the paper to the wall left a small white margin, which in some paintings became an integral part of the work. Within months, this new formal device would find its way into one of his final bodies of work, which would become known as his *Black-on-Gray* series.

**Sound Byte:**

*Rothko's mature paintings could be ravishingly beautiful, but was that enough to constitute a major religious utterance? One can only answer without skepticism that it was not.*

—ROBERT HUGHES, art critic, 1968

## A new start

On January 1, 1969, Rothko separated from Mell, his wife of twenty-four years, and moved into the East 69th Street studio. In that final year of his life, he began his last series, the black-on-gray paintings.

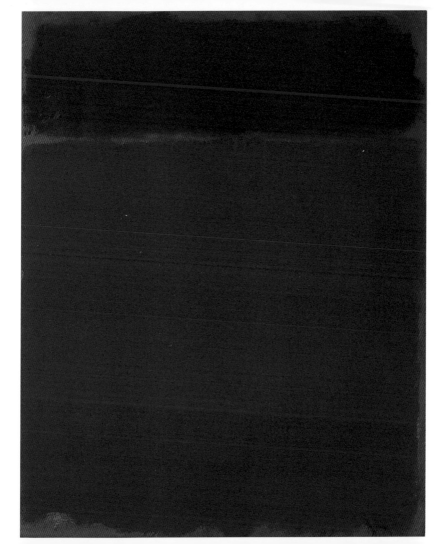

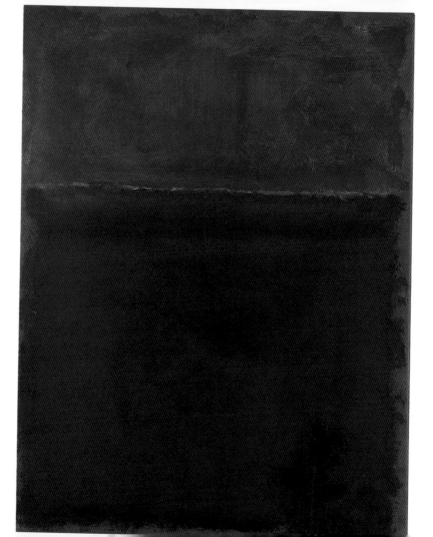

These highly controlled paintings marked another major departure for Rothko: Evolved formally from the Houston Chapel paintings and from his recent acrylic works on paper, they consisted of two contrasting straight-edge rectangles: one black, the other in various shades of gray. The black one, always on top, suggested upside-down landscapes, while the rectangles were surrounded at the edges by a thin white margin, first seen in the works on paper a few months earlier. The white margins enhanced the flatness of the works and thus rendered them Rothko's first truly two-dimensional paintings. This was a major innovation in his work. No more floating rectangles: Rothko's world had become flat—perhaps a reflection of the darkness of the artist's inner emotional state or of his perception of the world in which he lived.

OPPOSITE
*Untitled.* 1968
Acrylic on paper
mounted on
hardboard panel
32 $^{13}/_{16}$ x 26 $^1/_8$"
(83.3 x 63.8 cm)

## Descending from the Stage

In December 1969, Rothko gave a large party in his studio to present these new paintings to his friends and some knowledgeable followers. Little did his guests realize that this would be the last time many of them would see the artist alive.

On the morning of February 25, 1970, one of Rothko's studio assistants found the painter lying dead on the floor of his bathroom in a pool of blood. He had slashed the insides of his elbows with a razor blade.

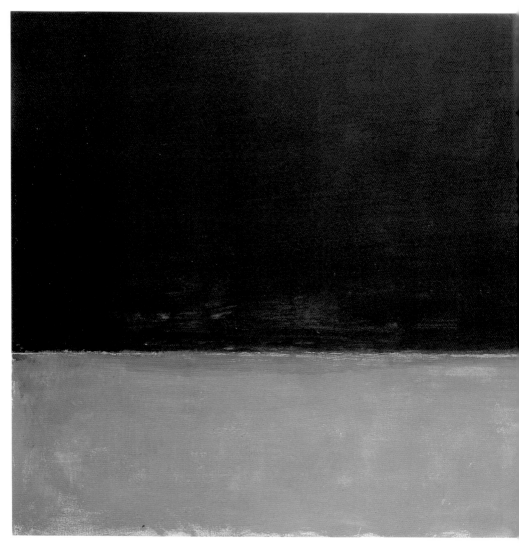

## An oeuvre complex and glorious

Rothko's monumental abstractions of ethereal color fields have no parallel in Western art. The artist invented his own rules as his creations emerged from within him. The combination of red and yellow generally produces orange, but when Rothko combined these two colors, they didn't necessarily lead to orange as we know it. Instead, his colors (and, therefore, his paintings) have their own emotion, sense of mystery, and meaning. Each of Rothko's works is larger than the sum of its parts. Yet he became an artist almost by chance, and an abstract painter against his will. Rothko regarded his art primarily as an ethical statement. Guided by Nietzsche, he saw himself fundamentally as a *moral* artist. He wished for his paintings to convey hope and faith in the good of human existence—and, like religion, to reflect the passion and complexity of human conflict. He intended his paintings to *increase* in emotional content as he reduced their shapes and colors. Consequently, his art has often been misunderstood: Some critics and art historians have labeled his canvases "action" paintings and "color fields," but neither description was acceptable to

OPPOSITE
*Untitled.* 1969
Acrylic on canvas
54 $\frac{1}{4}$ x 68 $\frac{1}{4}$"
(137.8 x 173.4 cm)

*Untitled.* 1969
Acrylic on paper
54 x 42 ¹/₄"
(137.16 x 107.32 cm)

Rothko. He saw his floating color rectangles as "objects" or as "actors" in an emotional drama that expressed universal human feelings on his canvases.

**Sound Byte:**
*In Mark Rothko's pictures, the apparent end lies close to the apparent beginning—so close, in fact, that they are almost indistinguishable.*
—ROBERT GOLDWATER, Rothko's authorized biographer, 1962

Rothko was also a *serial* painter: He almost always created paintings in series, beginning with his earliest works in the 1920s and culminating in his large-scale commissions for Seagram, Harvard, and Houston, and finally in his black-on-gray works. Once he reached his mature style, his paintings were mostly variations on a theme. One of his greatest achievements as a painter, much overlooked during his lifetime, was his ability to create dynamic and spiritual environments that could totally immerse the viewer. Thanks to this unique talent, he was the first true "installation artist."

To this day, Rothko's virtuoso handling of paint, which involved decision-making as well as technical skill and an extraordinarily rich heart, has mystified art historians and is admired by artists of all ages.

*I was always looking for something more.*

—MARK ROTHKO, 1970

Kate Rothko Prizel,
1971

Why did he commit suicide? Who knows, truly? Haunted by lifelong doubts about his work, this man of high moral and esthetic standards chose to step down from the stage when he felt that he was no longer able to maintain his principles and reach new artistic goals. He always remembered his Russian roots, and, despite the financial success and the honors bestowed upon him during his lifetime, he was never at peace in moving beyond the hardships of his childhood and the sadness of losing his father at such an early age. But perhaps his declining health and the demise of his marriage to Mell contributed to the artist's feelings of hopelessness.

**FYI:** Within five weeks of Rothko's death, the lease on his East 69th Street studio was assumed by Marlborough, which renamed the space "The Marlborough Studio." The gallery then hired two photographers to document one hundred works that Lloyd had pre-selected from Rothko's inventory of paintings. The canvases were photographed at night and stretched the next day, to be immediately picked up and sold by the gallery.

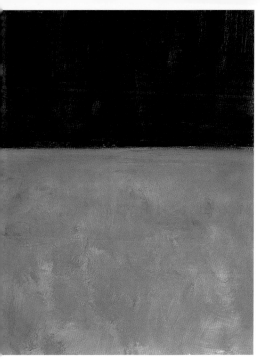

## The Marlborough Scandal

After Rothko's death, his daughter, **Kate Rothko Prizel** (b. 1950), filed suit against his executors and the Marlborough Gallery to gain control of her father's estate and to have 658 unsold paintings that Marlborough had illegally seized after the artist's death returned to her. On December 18, 1975, a New York court ruled in her favor. The gallery was ordered to return the paintings and to pay fines and damages totaling $9,252,000.00. The court's decision was upheld two years later at the appellate level. The sensational four-year trial revealed that Rothko had been betrayed by three of his most trusted friends who, as executors of his estate, had allowed the Marlborough Gallery to disperse 800 paintings at a fraction of their true market value. It also disclosed the shady business practices of Frank Lloyd, who was found guilty of conspiracy, double-dealings, phony sales, manipulating markets, and laundering profits. During the trial, Lloyd contemptuously told one reporter that he collected money, not art.

*Untitled.* 1969
Acrylic on paper
62 ½ x 48 ³/₁₆"
(158.75 x 122.56 cm)

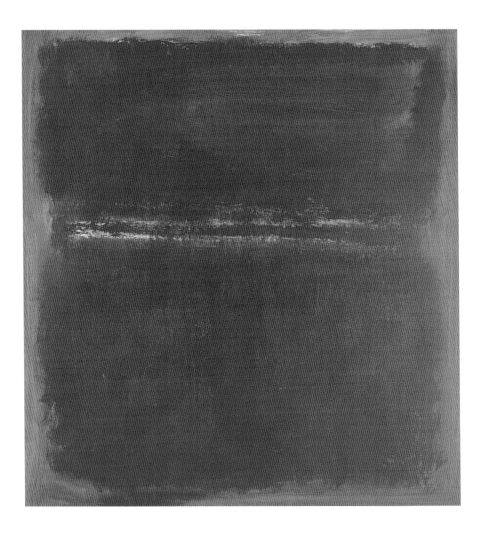

**Sound Byte:**

*The people who weep before my paintings are having the same religious experience I had when I painted them.*

—MARK ROTHKO, 1965

## The Journey

He began as a novice, a self-taught immigrant in the 1920s, but by the time of his death in 1970 he was one of the grand old men of American painting, having helped make New York the center of contemporary art. However, the glossy picture of an American success story hides the gritty struggles of an artist who strove for recognition and a sufficient way of expressing himself. The subjects of his early work often evoked the Depression era of the 1930s, but they possessed their own internal world that went beyond the troubles of money. From this psychologically informed brand of figuration and social realism, Rothko traveled to a land of Surrealism, seeking through myth a more direct means of communicating on the most primordial level.

The end of World War II invited a new sense of freedom, and, with it, Rothko and most of the other Abstract Expressionists moved into pure abstraction. Ironically, as his work abandoned the human figure and became more and more abstract, Rothko sought to make his paintings more human—to capture and speak to what is most essentially human in all of us.

OPPOSITE
*Untitled.* 1970
Acrylic on canvas
60 ¼ x 57 ⅛"
(152.4 x 145.1 cm)

By 1949, the blotchy colors of Rothko's *multiform* paintings had organized themselves into the familiar arrays of two or three colorful rectangles that became the artist's signature style. Many of his paintings of the 1950s were filled with brilliant reds and yellows, yet they never ceased to invite the viewer to turn inward for self-exploration. By the late 1950s, the colors had deepened to more meditative tones, but flashes of the earlier brightness still emerged from time to time. Even the darkest, blackest paintings often had layers of lighter colors underneath that gave them an eerie glow.

Rothko hoped to create a timeless art, one that would continue to communicate in an intensely personal way and not just reflect his own epoch. A grandiose aim, perhaps, but one that counts its success in the individual encounters of viewers from successive generations. For Rothko, each time a painting struck an inner chord with a viewer, he had taken another step toward realizing that goal.

759.13
OTT

# DATE DUE

| | | | |
|---|---|---|---|
| | | | |
| | | | |
| | | | |
| | | | |
| | | | |
| | | | |
| | | | |
| | | | |
| | | | |
| | | | |
| | | | |

Bethany Christian Schools Library
Goshen, Indiana

Bethany Christian Schools

3 0000 00011270 0